IMAGES
of America

ARCHDIOCESE OF DETROIT

George Applegate

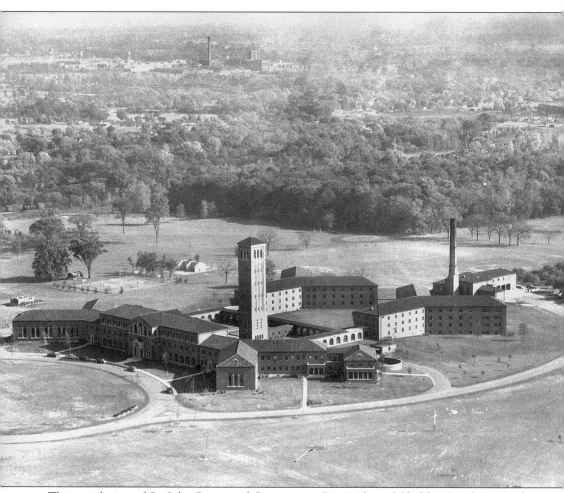

This aerial view of St. John Provincial Seminary at Five Mile and Sheldon Road in suburban Plymouth shows the complex as it nears completion in 1948. A 20-acre portion of the original 180-acre parcel of land was sold to the state of Michigan in 1965 to allow for the construction of the nearby M-14 highway.

IMAGES
of America

ARCHDIOCESE OF
DETROIT

Roman Godzak

ARCADIA

Published by Arcadia Publishing,
an imprint of Tempus Publishing, Inc.
3047 N. Lincoln Ave., Suite 410
Chicago, IL 60657

Printed in Great Britain.

Library of Congress Catalog Card Number: 00-107490

For all general information contact Arcadia Publishing at:
Telephone 843-853-20700
Fax 843-853-0044
E-Mail sales@arcadiapublishing.com

For customer service and orders:
Toll-Free 1-888-313-2665

Visit us on the internet at http://www.arcadiapublishing.com

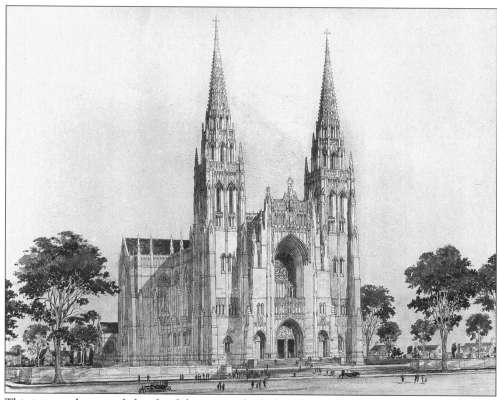

This is an architectural sketch of the new cathedral envisioned by Bishop Michael Gallagher for the Detroit Diocese sometime in the 1920s. The city's economic prosperity of that decade permitted the bishop to entertain such a grandiose dream but ironically, the plan never materialized.

CONTENTS

INTRODUCTION

When Henry Ford introduced mass production with the automotive assembly line, he radically transformed American, and ultimately, global commerce. The automobile evolved into more than just an expensive novelty for the wealthy, becoming instead an indispensable component of the national economy. Henry Ford's equally innovative move in 1914 to increase the wage of the average worker to an astounding five dollars a day was tantamount to Detroit laying a welcome mat at its doorstep and bidding the world to come. The world heeded the call.

At the conclusion of the First World War in 1918, the nascent automobile industry required greater numbers of laborers. Immigrants poured into Detroit from southern Europe—Italy, Malta, and the Balkan regions—Eastern Europe—Poland, Lithuania, Czechoslovakia, and the Ukraine. In addition to Europeans, Mexicans and African Americans migrated to Detroit from the south. Their common bond was their willingness to exchange the uncertainty of eking out a living from the soil for the lucrative, albeit dehumanizing, drudgery of the factory. Most of these newcomers were Catholic, bringing their traditions with them and making the Church their social and cultural nucleus. In that same year, Michigan-born Michael Gallagher became Bishop of Detroit, the first native son to attain that honor. It was upon his shoulders that the burden fell of ministering to this growing mix of humanity.

At the time of Gallagher's appointment, the Detroit Diocese comprised all counties in lower Michigan south of Ottawa, Kent, Montcalm, Gratiot, and Saginaw counties, east of Saginaw and Bay counties, covering a territory of over 18,500 square miles and a total Catholic population of over 386,000. Of the over one hundred new parishes established by Bishop Gallagher during his two-decade tenure, more than a third were for non-English-speaking Catholics. Each ethnic group vociferously defended its cultural heritage, demanding its own parishes and priests. Temporary churches, some nothing more than glorified garages, were hurriedly constructed throughout the city as the Detroit Diocese valiantly attempted to keep abreast of its burgeoning responsibilities.

The xenophobic decade of the 1920s saw an increase in anti-immigrant and anti-Catholic activities, highlighted by the national revival of the Ku Klux Klan. In Michigan, the state legislature twice attempted to outlaw parochial schools. Bishop Gallagher led the fight in 1920 and 1924 to defeat the proposed legislation. In the face of this bias, Gallagher continued to

build up the Church's presence in Detroit, making the city, in effect, a Catholic stronghold.

The consequences of the Great Depression, that began with the stock market collapse in 1929, turned Detroit into a political hotbed and a social nightmare. Nationally the unemployment rate stood at 25% while in Detroit, that figure was doubled. Church and school construction abruptly ceased as the diocese found itself mired in debt while the same immigrants, so eagerly sought only a short time earlier, were now the first to be thrown onto the streets. The Capuchin Friars of Detroit, headquartered at St. Bonaventure Monastery, established their soup kitchen in 1930, feeding the destitute who stood in bread lines that snaked for several blocks. Among the friars who labored there was an obscure monk named Solanus Casey, now a candidate for sainthood. Meanwhile another diocesan priest was making a name for himself across America.

Fr. Charles Coughlin, a gifted, mesmerizing orator, had the idea to utilize the radio, itself a recent innovation, to broadcast religious programming locally. As the Depression worsened, however, Coughlin's religious themes gradually turned political as the cleric blasted public officials and bankers with allegations of corruption and a conspiracy of the wealthy that condemned the working class to a life of misery. Soon other radio stations aired Coughlin's program and the dispirited unemployed, who nationally numbered in the tens of millions, at last had their spokesman and champion.

In 1937, Edward Mooney succeeded Bishop Gallagher, while simultaneously the Detroit Diocese was elevated to an Archdiocese. Mooney's most pressing order of business was to somehow extricate his see from the financial quagmire brought on by the Depression. That objective however, was overshadowed by the onset of the Second World War. The city's immeasurable contribution to the war's successful outcome would put Detroit into the pages of 20th century history. Detroit was honored once again in 1946 when Archbishop Mooney was made the Archdiocese's first cardinal, but along with the new distinction came new obligations as thousands of war refugees descended upon Detroit to seek work in the auto plants just as their predecessors had done a generation earlier. The Archdiocese played an active role in the resettlement of these new residents, a service that continues to this day.

The 1950s saw America's economy rejuvenated as consumers, tired of their wartime sacrifices, were eager to spend money. Detroit's auto industry continued to hum along at a brisk pace, offering steady, good-paying jobs to anyone who sought them. The Archdiocese shared in this prosperity as more new parishes were established, not only within city limits but also increasingly in the suburbs. The first "baby boomers" were now of school age and classroom construction could not keep pace with demand as youngsters filled every Catholic school to capacity. The Archdiocese, out of necessity, expanded its various social service and charitable ministries to include more child and youth care facilities, religious education, residences for the aged, and programs for the physically and mentally challenged. Despite these notable achievements locally, the nation as a whole had an underlying moral and spiritual crisis that came to a climax in the following decade.

Prejudices deeply ingrained in American society for generations were being challenged in the 1960s by African Americans who demanded their rights as guaranteed them by the Constitution. Civil rights issues were placed on the forefront as Catholic Detroiters, led by Archbishop John Dearden, were compelled to examine their collective conscience in the face of racial and social injustice. Ideas translated into action as the Archdiocese informed local businesses that discriminatory hiring practices were unacceptable and those guilty of such transgressions would no longer do business with the Catholic Church. Seminars and conferences were organized to educate Detroit Catholics that bigotry was incongruent with church teaching.

Urban renewal projects became widespread during the 1960s and often targeted older, ethnic neighborhoods for razing. To replenish diminishing residential housing, federal grant funds were given to municipalities for redevelopment purposes. The Archdiocese, working with city and neighborhood agencies, co-sponsored efforts with names like the Phoenix Project and the

Riverside Townhouse Project that provided affordable dwellings for lower income families.

Detroit today, though remaining among the larger cities in the United States, is smaller than it was during its peak period in the mid-20th century. Like most urban centers across America, it faces numerous difficulties: debilitating poverty, a deteriorating infrastructure, and a declining tax base. There is however, an abundance of hope, vision, and determination. The Archdiocese of Detroit, today comprising six counties with a territory of just under 4,000 square miles and a Catholic population of 1.3 million, will also address its exigencies and fulfill the promise of a better future by remaining true to its original mission of helping those in need.

Roman Godzak
August 2000

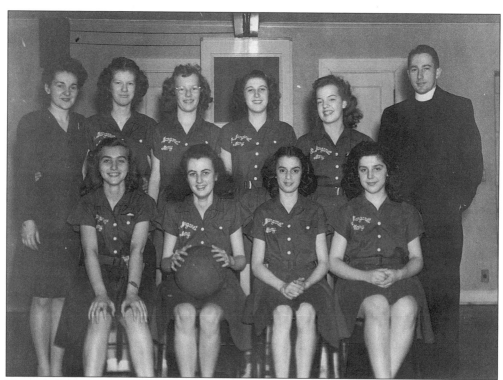

The girls' basketball team from St. Margaret Mary Parish on Detroit's east side poses for a group photo in 1945. Standing at the right is the associate pastor, Fr. Joseph Breitenbeck, who would be made an auxiliary bishop of the Archdiocese in 1965 and just four years later, ordained Bishop of Grand Rapids.

One
THE TWENTIES
ECONOMIC BOOM

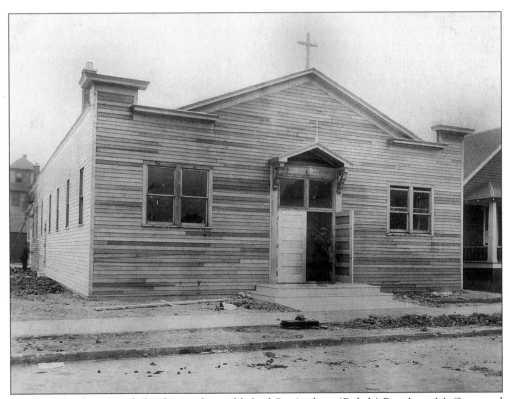

This was the first church for the newly established St. Andrew (Polish) Parish on McGraw and Larkins on Detroit's west side in 1920. The hastily constructed building typified the temporary worship structures that sprang up as the city's population swelled dramatically during the 1920s.

Bishop Michael Gallagher, who served the Detroit Diocese from 1918 until 1937, was nicknamed "the building bishop." He oversaw the establishment of more than one hundred new parishes within the diocese during his tenure.

The Jefferson Theater was converted into a makeshift church on Sundays to accommodate the parishioners of St. Rose of Lima in 1920 until the necessary funds were raised to begin construction of a more appropriate worship facility.

One of the largest and best known child care facilities in Detroit was the St. Francis Home for Orphan Boys on Fenkell at Linwood on the west side. This new building was erected around 1920 to house the over five hundred boys placed in the care of the Sisters of St. Joseph.

Santa Maria Parish, on Cardoni and Rosedale Court in Detroit, served the growing numbers of Italians who were leaving their old neighborhoods in downtown Detroit for the city's northern outskirts. Santa Maria was located near the cusp of the boundaries for Detroit, Highland Park, and Hamtramck. Shown here are the church and rectory in the early 1920s.

Our Lady of Guadalupe Parish was founded in 1920 on Roosevelt and Kirby on Detroit's near west side for the city's Mexican population. The congregation at Our Lady of Guadalupe, however, never grew considerably as many Mexican residents attended churches closer to their own homes to save the cost of streetcar fare, especially during the Depression.

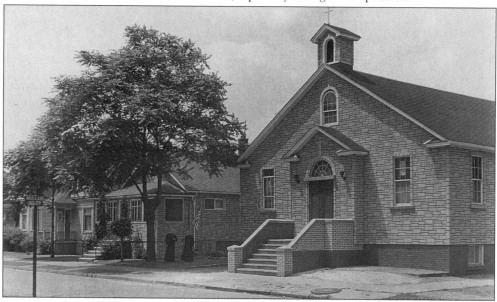

St. Peter Parish, on Longworth and Mullane in southwestern Detroit's Delray section, was established in 1920 for Lithuanians who labored in the area's heavy industries. With only minor exterior modifications, the temporary church eventually became the permanent facility, continuing to serve Detroit's Lithuanians until the parish was closed in May 1995.

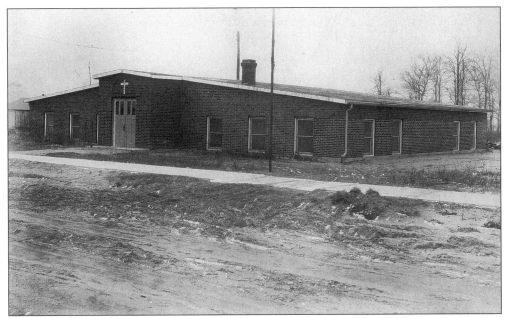

The temporary church built in 1921 for Guardian Angels Parish (presently on Fourteen Mile Road in Clawson) was considered an improvement over similar structures in that it was made of brick rather than wood.

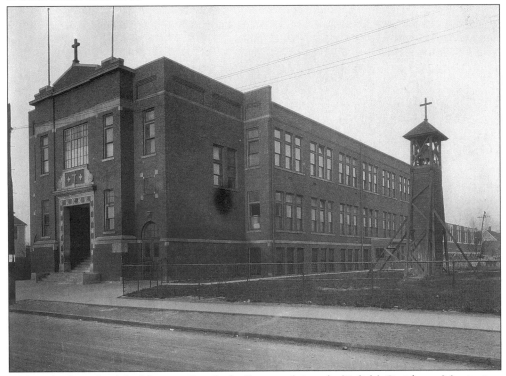

Although the school building at Our Lady Queen of Angels (Polish) Parish on Martin just south of Michigan Avenue did not incorporate a bell tower into its design, so the innovative parishioners built their own to summon the neighborhood children to classes each morning.

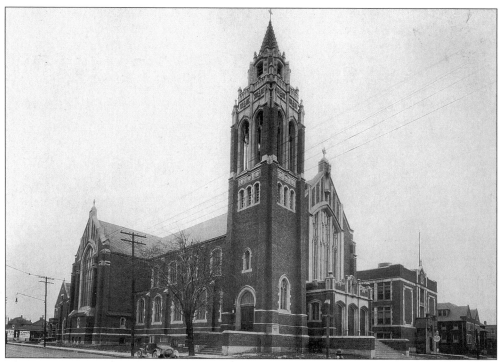

The permanent church building for St. Agnes Parish, founded in 1914, was completed in 1922. Situated at the corner of Twelfth and LaSalle Gardens, the building would be struck by stray bullets fired during the Detroit riots in the summer of 1967.

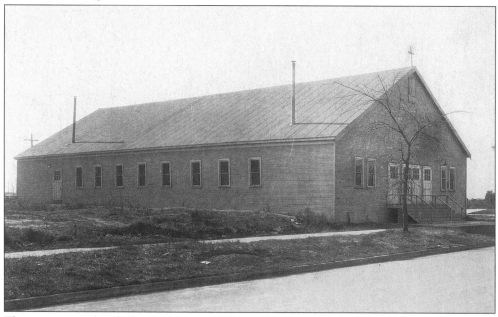

The temporary church for St. Martin of Tours Parish, established in 1923, was located on Drexel and Ellsworth Court in Detroit between Jefferson Avenue and the Detroit River. Even after the construction of a permanent church, these rudimentary facilities often continued to function in many parishes as auditoriums, activities centers, or school gymnasiums.

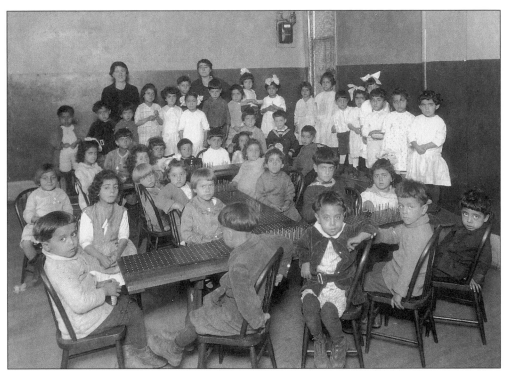

The League of Catholic Women provided invaluable assistance to working immigrant parents by operating a day care service for small children. In many cases, both parents needed to work because one salary was insufficient to support the entire family.

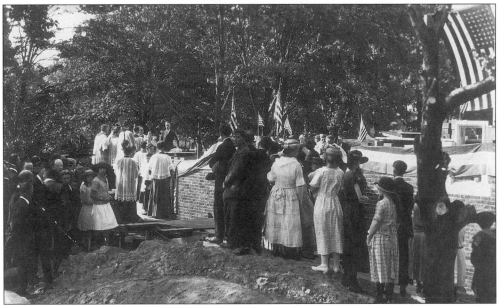

Parishioners gather to witness the blessing of the cornerstone of the new St. Mary Church in the city of Wayne in 1923. The parish dated back to 1862, in the days when the area along Michigan Avenue in western Wayne County was populated mainly by farmers and a few shopkeepers.

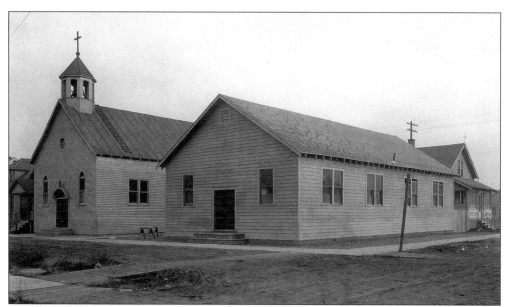

Our Lady Help of Christians Parish was founded in 1923 on McDougall and Halleck, just north of the Detroit-Hamtramck boundary and south of what is now the Davison Expressway. The temporary church and school building sat in a new subdivision amid unpaved streets and portions of sidewalk that consisted of wooden planks.

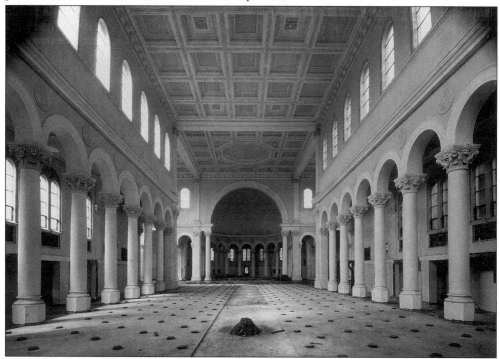

Holy Redeemer Parish, founded in southwestern Detroit in 1880 and currently located on Junction between Michigan Avenue and Fort Street, began construction of a larger church (the present structure) in 1923. Shown here is the unfinished interior without pews. The building would be formally dedicated in 1924.

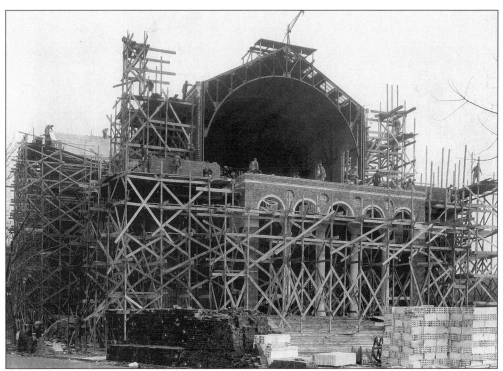

Workers clamber over an elaborate network of scaffolding while constructing the permanent church for St. Theresa of Avila Parish on Pingree and Quincy, two blocks east of Grand River, in 1924. The parish was established in 1915.

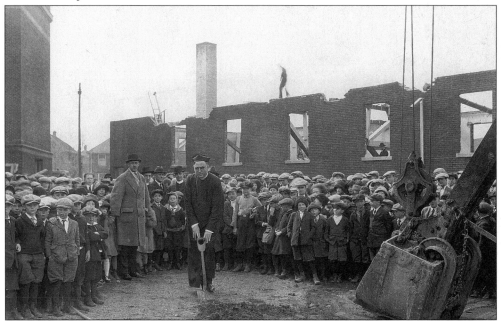

Surrounded by curious onlookers, Fr. John J. McCabe, founding pastor of St. Theresa of Avila, turns the symbolic shovel of dirt in preparation for the final stages of construction of the new church and rectory in the spring of 1924.

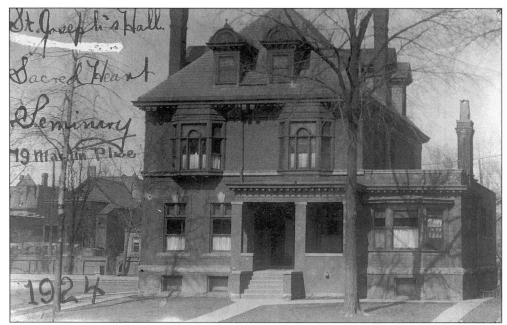

Before the completion of the present campus at the corner of West Chicago and Linwood on Detroit's near west side, Sacred Heart Seminary traces its historic roots to St. Joseph's Hall at 79 Martin Place, established just after the end of the First World War.

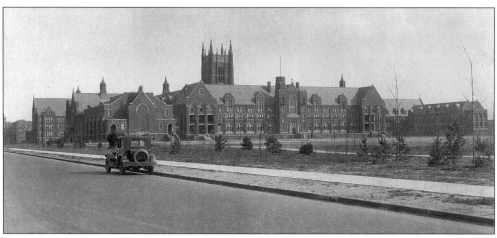

Opened in 1924, the Sacred Heart Seminary complex was undoubtedly the pride and joy of Bishop Gallagher. No longer would Detroit-area seminarians be sent out-of-state for their studies and risk being turned down for a lack of classroom space. The diocese was now free to educate its own priests locally to satisfy the tremendous demand for their services.

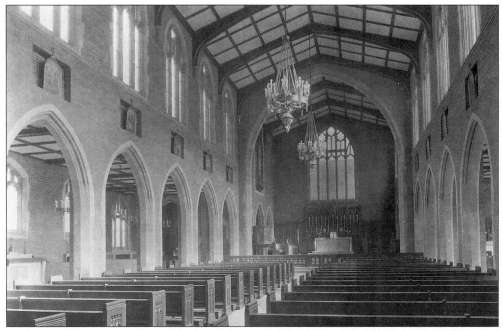

With its Gothic arches and richly detailed features that evoked feelings of both majesty and serenity, the chapel at Sacred Heart Seminary was, in essence, a scaled-down version of the type of interior prevalent in western European cathedrals.

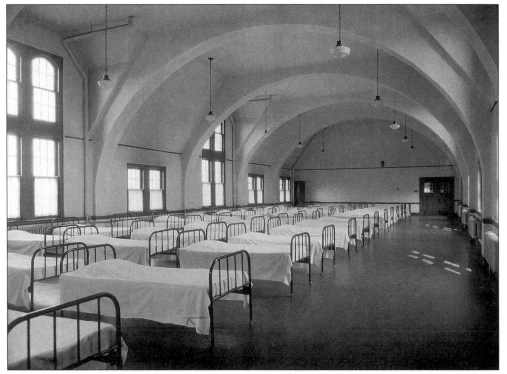

By contrast, the seminary dormitory, with its sparse "décor" and neatly arranged Murphy beds, was intended to be simply functional, accommodating up to 350 boarding students.

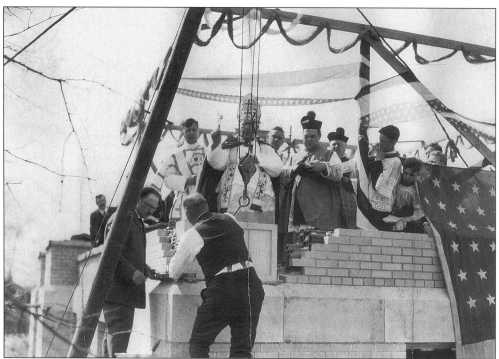

Bishop Gallagher blesses the cornerstone at the new St. Louis the King Church, located on Seven Mile Road and Mt. Elliott in northeastern Detroit in 1924. The parish was founded one year earlier for the area's Polish residents who were relocating from their older inner city neighborhoods to what was then considered to be Detroit's outskirts.

This former Protestant church on Oakland and Melbourne in Detroit was purchased in 1924 by a group of Croatian Catholics and renamed St. Jerome. The parish remained at this location for 30 years before moving to the Eight Mile and Woodward area in 1955.

The architecture of St. Brigid Parish, founded in 1924 on Schoolcraft near Greenfield on Detroit's west side, displayed a quasi-Byzantine influence with its large, rounded roofline. The parish was closed in 1989 as part of a massive downsizing effort by the Archdiocese.

One of the older parishes in the Archdiocese, St. Francis Xavier (1847) in the downriver community of Ecorse, built a new school in 1924 to accommodate its nearly four hundred students. At right is the new convent that would be home to the Sisters of St. Joseph who staffed the school.

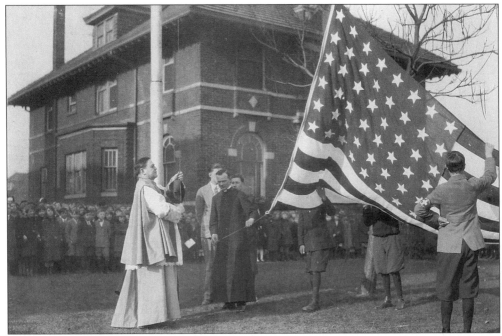

Msgr. John Doyle, Chancellor of the diocese, standing at left, participates in a flag-raising ceremony to commemorate Armistice Day at Assumption of the Blessed Virgin Mary Parish on Lovett near West Warren in Detroit, November 1925. Assumption's Polish congregation honored both native Poles and Polish-Americans who lost their lives during World War One.

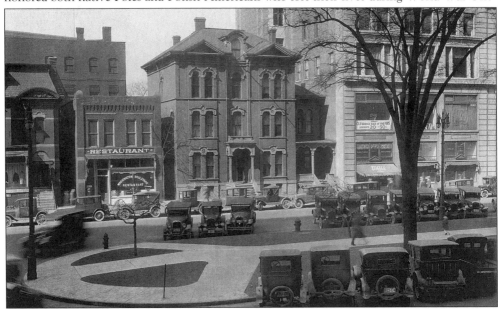

For over 50 years, the bishop's residence was on Washington Boulevard in the heart of downtown Detroit. In the later years of the 1920s, every structure in this photo (with the exception of the Book Building at the far right) was demolished and replaced with modern office and retail buildings, compelling Bishop Gallagher to begin construction of a new episcopal residence in Detroit's Palmer Woods subdivision.

St. John the Evangelist Parish, established in 1892 on the corner of East Grand Boulevard and Sargent, had built a modern physical plant by 1925 consisting of, from left to right, a rectory, church, and school. In 1981, the parish was forcibly closed and the facility leveled as part of the controversial land acquisition project for a new General Motors assembly plant.

These eighth graders from St. Rose of Lima Parish in Detroit c. 1925 typify the Catholic school students of the decade. Although a formal dress code consisting of a school uniform was not yet in place, all pupils were expected to dress appropriately with minor concessions to prevailing fashion trends.

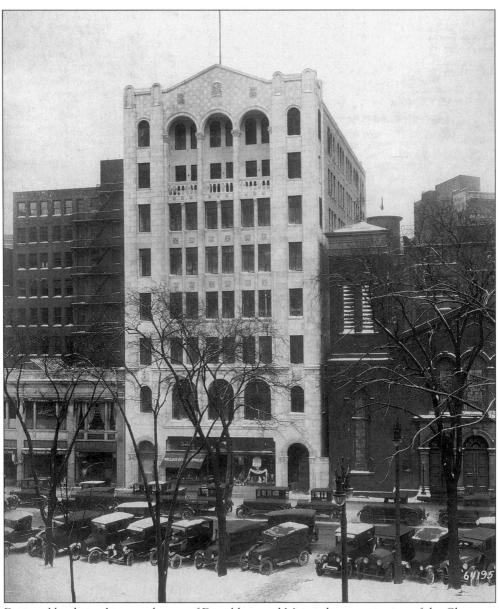

Designed by the architectural team of Donaldson and Meier, the construction of the Chancery Building at 1234 Washington Boulevard in downtown Detroit in 1926 represented the beginning of the modern era in the administration of the Catholic Church in southeastern Michigan. New departments staffed by personnel with expertise in different areas would now be required to provide more services for increasing numbers of Catholics. The Chancery continues to function to this day at its original location. At right is St. Aloysius Church prior to its renovation.

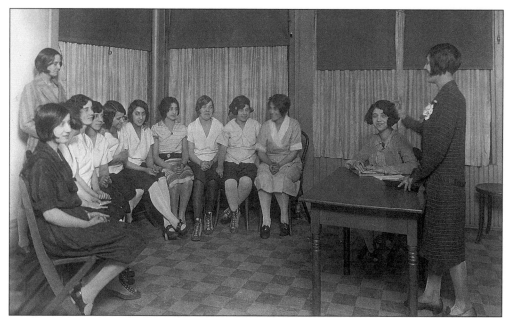

The Weinman Girls Activities Club, sponsored by the League of Catholic Women, provided an opportunity for the daughters of immigrant parents to meet regularly for both recreational and educational needs. The purpose of such groups was to gradually acclimate foreigners to American life.

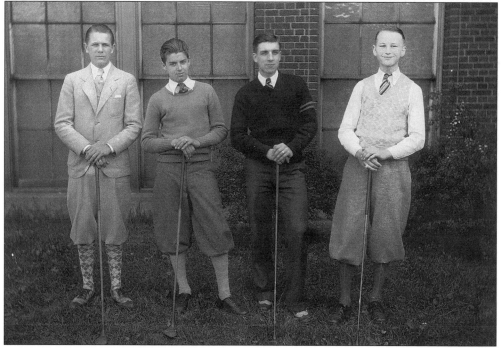

Looking stylish in the latest golfing apparel, these boys from St. Rose of Lima give evidence of the rising popularity of the game during Detroit's boom years of the 1920s. Golf was widely viewed as the "gentleman's sport," enjoyed by successful individuals.

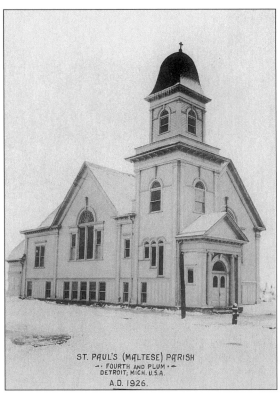

ST. PAUL'S (MALTESE) PARISH
- · FOURTH AND PLUM · -
DETROIT, MICH. U.S.A.
A.D. 1926.

St. Paul Maltese Church, located on the corner of Fourth and Plum in downtown Detroit, was the religious and cultural nucleus for the city's Maltese community, the largest such ethnic concentration in the nation in the 1920s. By 1952, however, the church and the surrounding neighborhood were razed for the construction of the John Lodge Expressway.

St. Dominic Parish, on West Warren and Trumbull, was founded in 1926 to appease persons living on what was then the far eastern boundaries of St. Leo Parish (at 15th and Grand River) who disliked the long trek to Sunday services. Today St. Dominic and St. Leo house the Detroit chapter of Mother Teresa's Missionaries of Charity Sisters.

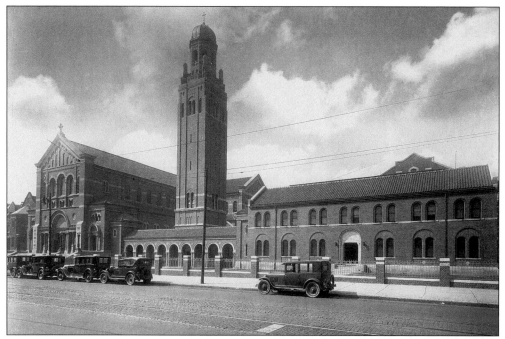

The final piece of the newly built Holy Redeemer Church on Junction was the bell tower called the Campanile. The tower was dedicated in 1926 to the memory of the sons of the parish killed in action during the First World War.

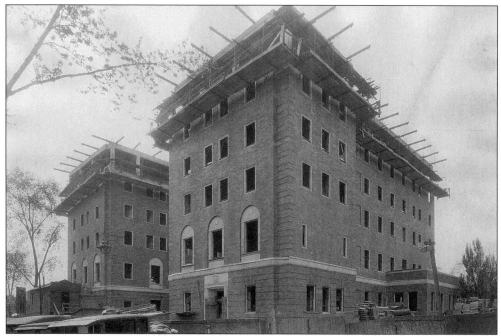

By 1927, the League of Catholic Women had grown into a substantial organization, requiring the construction of a new, multi-purpose activities building and headquarters located at 120 Parsons just north of downtown Detroit. Eventually the building would be named Casgrain Hall in honor of Anastasia Casgrain, one of the League's co-founders.

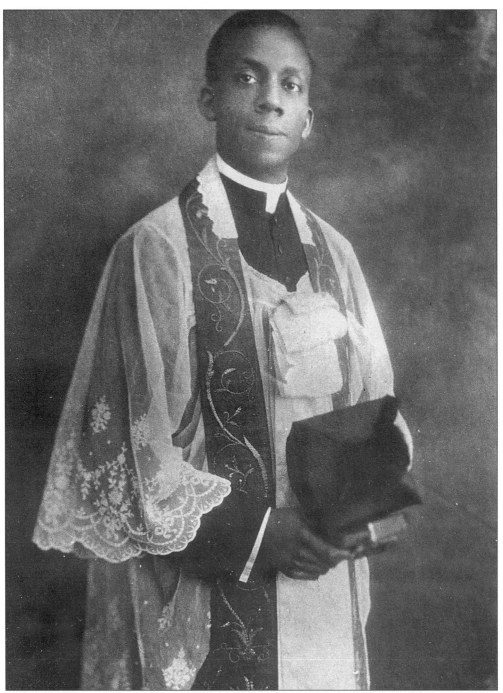

History was made in Detroit in 1927 when Fr. Norman Dukette became the first African-American priest ordained for the diocese. Fr. Dukette was assigned the task of organizing the first parish for African-American Catholics on Detroit's west side. The parish, located on Beechwood and Begole, was christened St. Benedict the Moor. Fr. Dukette stayed as pastor at St. Benedict for only two years before being reassigned in 1929 to Christ the King, another African-American parish in Flint, where he remained until his death in 1979.

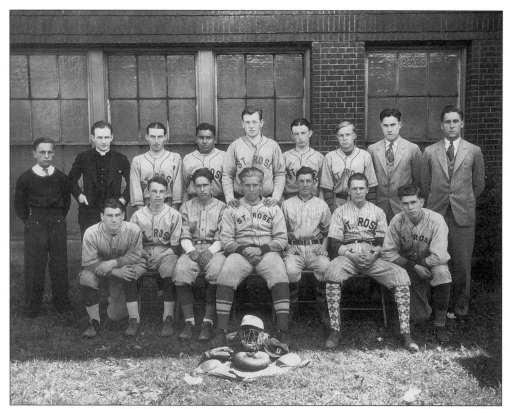

The St. Rose of Lima High School baseball team poses for a group photo, c. 1927.

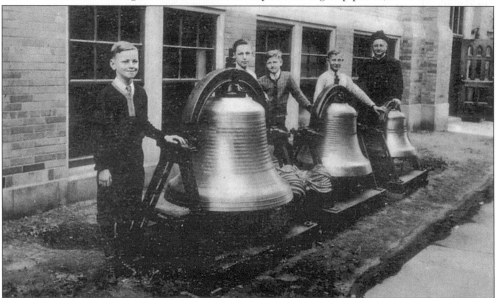

St. Cunegunda Church, a Polish parish, was founded in 1927 on Detroit's west side on St. Lawrence between McGraw and Kirkwood, north of Michigan Avenue. Here a group of boys stands proudly with the founding pastor, Fr. Alexander Wilczewski (at far right), awaiting the installation of their new church bells in 1928.

Shown here is the first class of graduating eighth graders from St. Edward Parish, c. 1928. St. Edward was established in 1927 on the corner of Crane and Kolb, just south of Mack Avenue on Detroit's lower east side. Sitting at center in the first row wearing glasses is St. Edward's founder, Fr. Ernest de Puydt.

Since its founding in 1920, St. Rose of Lima Parish had already built a new rectory, convent, and school but still had no permanent church. At long last in July 1927, construction began on a new worship facility on the corner of St. Jean and Kercheval, one block north of Jefferson Avenue.

Barely visible through the trees, the new St. Rose of Lima Church nears completion in the summer of 1928. The long-held dream of St. Rose's founding pastor, Fr. Edward Taylor, was quickly becoming a reality. The new church was dedicated later that year.

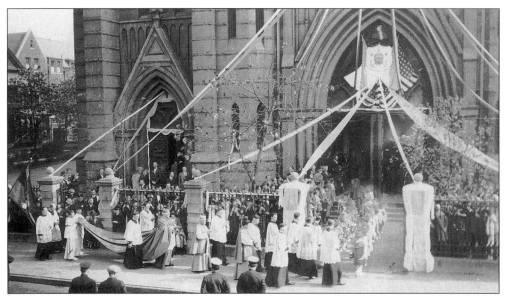

With his long, flowing cape carried behind him, Bishop Gallagher participates in a solemn procession into Sweetest Heart of Mary Church on the corner of Russell and East Canfield in Detroit in 1929 to mark the 40th anniversary of the parish. Also in the procession is Most Rev. Casimir Plagens, Detroit's first Polish auxiliary bishop who served as Sweetest Heart of Mary's pastor.

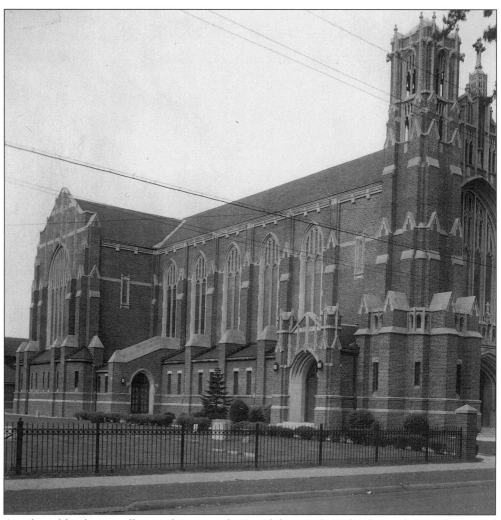

Another older, historically significant parish, St. Alphonsus (1852) is located on Calhoun and Gould in Dearborn, just north of West Warren along Dearborn's eastern boundary with Detroit. The present building, pictured here, was designed by Arthur DesRosiers. The cornerstone was placed in late 1928 and construction of the edifice proceeded for the next 18 months. The massive, ornate architecture symbolized the financial solidity of Detroit in the 1920s. A prosperous economy permitted almost continual construction of new churches and schools throughout the diocese. No one could have imagined, however, that the good times would soon come to a crashing halt.

Two

The Thirties

The Depression and Retrenchment

As economic conditions in Detroit worsened after the onset of the Great Depression, local charities were severely strained in their attempts to help the unemployed. The Capuchin monastery, St. Bonaventure, on Mt. Elliott north of Jefferson Avenue, opened its soup kitchen in 1930, feeding up to two thousand men a day.

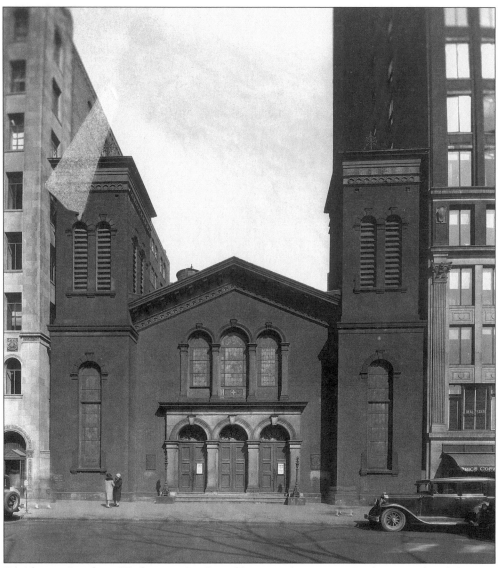

St. Aloysius Parish on Washington Boulevard began its history as a Presbyterian church but was purchased by the diocese in 1873. Over the years, St. Aloysius became a mainstay in downtown Detroit, initiating in 1916 what would become a favorite tradition for Catholic office workers and shoppers alike, the weekday noon Mass. Beginning in April 1930, the church exterior would undergo a renovation to complement the recently built Chancery, visible at left. St. Aloysius is seen here before. . .

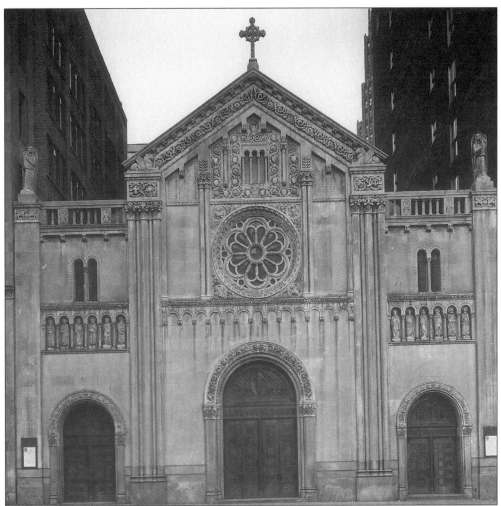

. . . and after. Once again, the creative abilities of Donaldson and Meier, designers of the Chancery, were called upon. The result was a transformation of the St. Aloysius facade that was breathtaking. The light gray granite utilized for the Chancery was also used in the St. Aloysius renovation, producing the appearance of a unified, seamless flow between the two structures. The intricate carvings, such as the Rose window above the main entrance and the figures of the apostles over each side entrance, were sculpted by Corrado Parducci. The church was dedicated in October 1930, highlighted by a grand parade on Washington Boulevard featuring a Knights of Columbus honor guard.

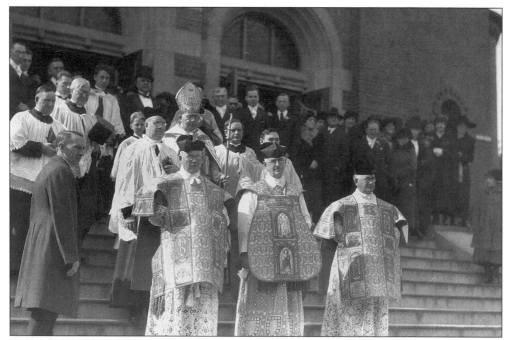

Bishop Gallagher visits Annunciation Church on Parkview one block north of Jefferson Avenue in 1931 to commemorate its 25th anniversary. Standing at the foot of the steps in the center is Msgr. James Stapleton, Annunciation's founding pastor.

Extracurricular activities were seen as an integral part of a seminarian's education. Sacred Heart Seminary's young men organized a school orchestra and recruited the musically inclined from among their ranks, c.1931.

Fr. Charles Coughlin began his rise to fame in 1930 with his religious radio program. As the suffering brought about by the Depression began to spread however, his dramatic, almost hypnotic speaking ability would soon gain him a national audience eager to hear his theories behind the country's economic plight.

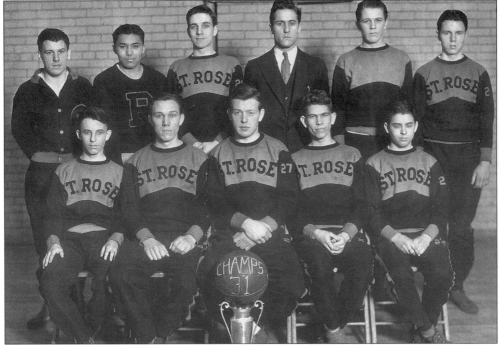

Detroit teetered on the brink of economic collapse by 1931, yet despite the tribulations endured by the average working man, the city's youth managed to provide an occasional moment of self-respect. The St. Rose High School varsity basketball team poses with its trophy as the league champions that year.

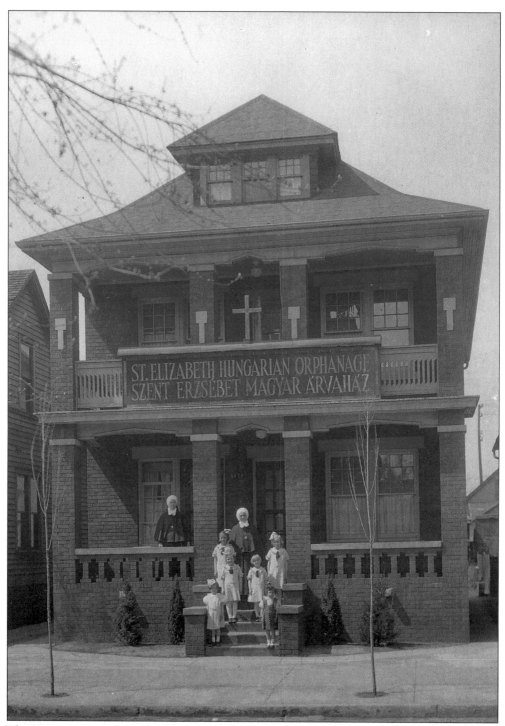

The Hungarian community in Detroit's Delray section operated an orphanage on South Street during the Depression, staffed by the Daughters of Divine Charity. Like other European immigrants in Detroit, the Hungarians' spirit of self-sufficiency prompted them to do what they could to help their own people through hard times.

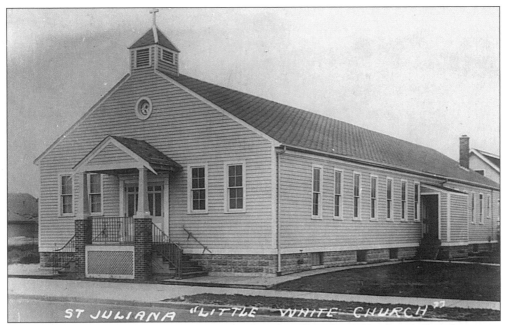

St. Juliana Church in Detroit was one of only a handful of parishes founded in the entire diocese during the 1930s, as the Depression tightened its grip on the nation. Shown here is the temporary structure built in 1932 at Chalmers and Longview.

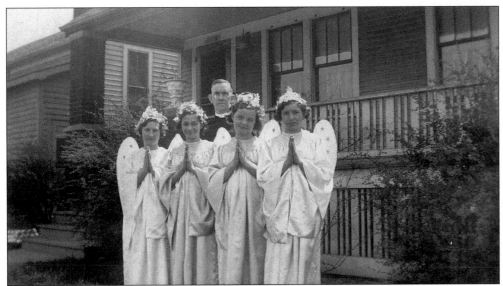

Despite massive unemployment in the city, people attempted to carry on with their lives as best as they could, still enjoying the familiar rites of passage within the Catholic faith. These four angels served as escorts for the first Holy Communion class from St. Juliana in 1933.

Fr. Coughlin's popularity soared nationally by the mid-1930s as millions of angry, desperate people embraced his message. The radio priest soon needed to recruit additional secretaries to respond to the avalanche of fan mail that poured into his office from around the country.

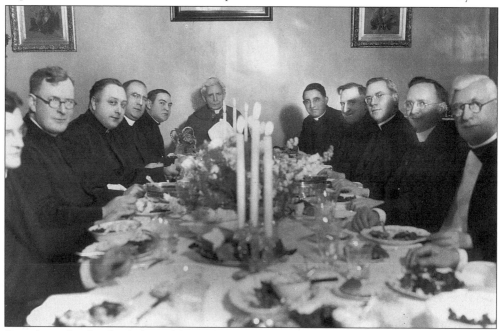

Seated at the head of the table, Bishop Gallagher marks the 75th anniversary of the establishment of the St. Joseph Retreat in Dearborn with a group of his priests in 1935. The St. Joseph Retreat was the first private psychiatric hospital in Michigan, staffed by the Daughters of Charity.

The League of Catholic Women sponsored a Christmas program for a group of young immigrant women in 1936. With many of their families experiencing financial hardship, this type of gathering would be the only opportunity for them to celebrate the holiday season.

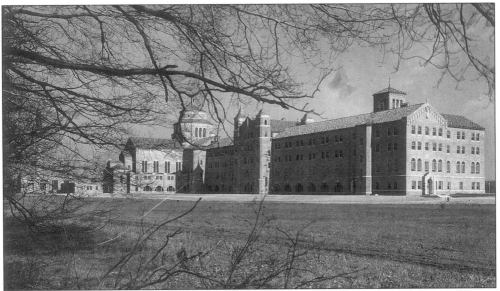

In 1936, the Felician Sisters relocated their motherhouse from its original location in Detroit's oldest Polish neighborhood on St. Aubin across from St. Albertus Church to a new, more spacious facility in the suburb of Livonia. It continues to serve as the nucleus for the Felicians in the Archdiocese to this day.

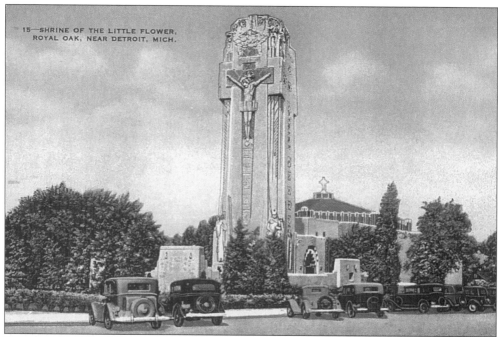

While many other parishes in the Detroit Diocese were struggling financially, the generosity of Fr. Coughlin's supporters across the United States permitted the construction of a magnificent church for the Shrine of the Little Flower Parish at the corner of Twelve Mile and Woodward in Royal Oak, with its trademark stone cross tower, in 1934.

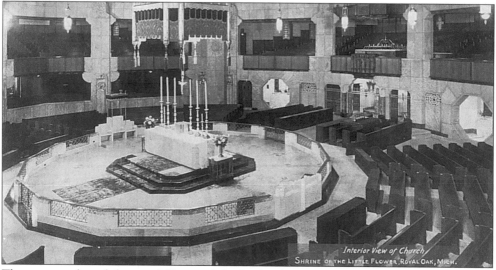

The octagon-shaped design of Shrine of the Little Flower Church produced an interior that permitted an unrestricted view of the altar at center. The seating capacity is estimated to be three thousand.

Bishop Gallagher blesses the cornerstone for the new permanent church for Detroit's Slovaks, SS. Cyril and Methodius, on Centerline and Marcus near the Detroit-Hamtramck boundary in 1936. In that same year, the parish pastor, Fr. Joseph Zalibera, petitioned the Detroit City Council to change the street name from Centerline to the more fitting St. Cyril. The request was unanimously approved.

This stone church at St. Hugo of the Hills Parish in Bloomfield Hills was dedicated in 1936. St. Hugo is the only church in the history of the Archdiocese to be funded solely by private donations. The wealthy McManus family paid for the construction of the church as a memorial to their two deceased sons.

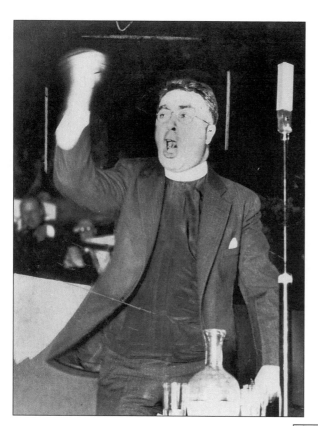

By the late 1930s, Fr. Coughlin's message became increasingly ominous in tone and his politics more extreme. His once loyal listeners gradually fell away and, shortly after the beginning of the Second World War, impending federal charges of sedition against the iconoclastic priest finally forced him out of the public spotlight.

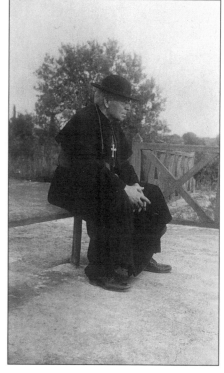

The camera captures a weary Bishop Gallagher in a rare moment of rest. The Coughlin controversy, a diocese staggering under the crushing weight of debt brought on by the Depression, and his own declining health were taking their toll on the aging prelate.

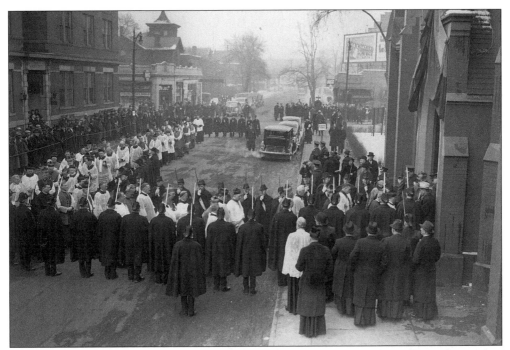

An honor guard composed of members of the Knights of Columbus awaits at either end of Adelaide near John R. in Detroit for the beginning of funeral services for Bishop Gallagher in the old St. Patrick Church, which at that time served as the diocesan cathedral. The bishop's death on January 20, 1937 marked the end of an era in the history of the diocese. Later that year, the Vatican elevated Detroit to an Archdiocese.

The funeral motorcade makes its way out of Detroit to Holy Sepulchre Cemetery in Southfield, Bishop Gallagher's final resting place.

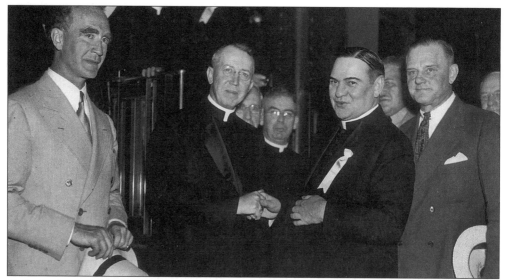

Gallagher's successor was Most Rev. Edward Mooney, the first prelate to bear the title Archbishop of Detroit. Mooney, at center, is greeted at the train station upon his arrival into the city on August 1, 1937 by Chancellor Msgr. John Doyle. At far left is Frank Murphy, the Catholic governor of Michigan and former mayor of Detroit.

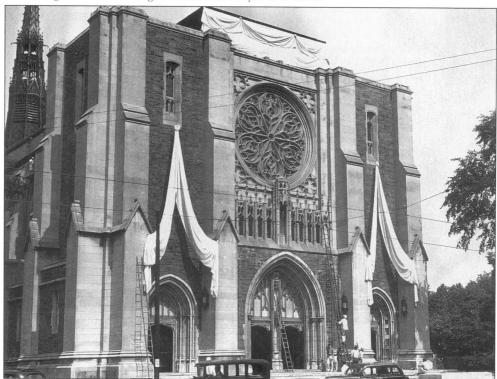

A rare shot of Blessed Sacrament Church on Woodward Avenue without its spires as workers put the finishing touches on the colorful decorations to welcome the new archbishop. Although not yet officially declared as the cathedral, Blessed Sacrament was the chosen site for Mooney's installation ceremonies.

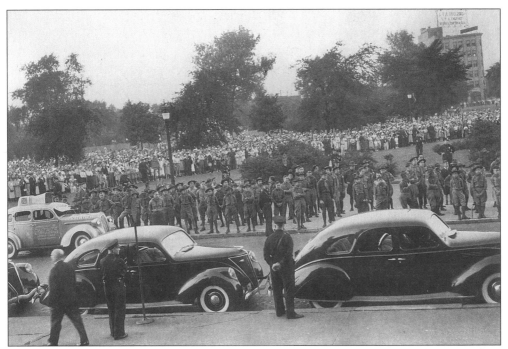

Crowds gather in the vicinity of Blessed Sacrament Church hoping to catch a glimpse of their new spiritual leader.

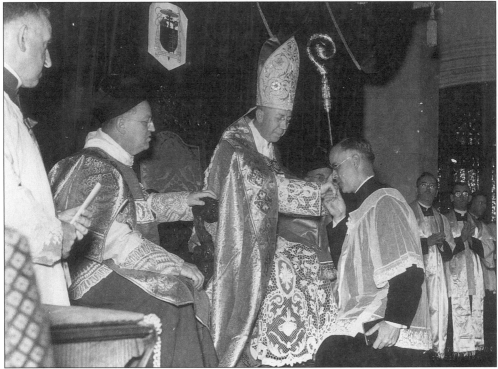

A priest kisses the ring of Archbishop Mooney at his installation ceremony, August 3, 1937, symbolic of the new beginning in the history of the Catholic Church in southeastern Michigan.

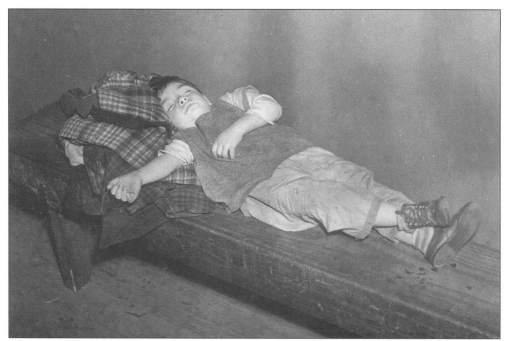

This shot of a boy sound asleep on a bench was used by the League of Catholic Women in 1937 as part of a fund-raising campaign to illustrate the needs of the less fortunate. The debilitating effects of the Great Depression had spurred many women to volunteer their services on behalf of the League and its affiliated charities.

Children in the kindergarten class at St. Peter Claver Church at Beaubien and Eliot in Detroit flash their best smiles for the camera in 1937. St. Peter Claver was the first African-American Catholic parish in Detroit, established in 1911. When the sizeable congregation outgrew its original property near the Brewster Housing Projects, Archbishop Mooney, in 1938, turned nearby Sacred Heart Parish over to African-American Catholics as their new church.

Students at the St. Bernadette Mission in southeastern Dearborn near the Detroit boundary pose for a group photo in 1938. St. Bernadette was founded for the Italians and Maltese living in the area, most of whom labored at Ford Motor Company's sprawling Rouge assembly complex. In 1943, the mission was elevated to full parish status.

At the southern end of the Archdiocese in the city of Monroe, students at St. Joseph Parish gather in front of their school in 1938. Although some industries were present, this part of Michigan near the Ohio border was still primarily farm country.

Holy Ghost Parish, in the Seven Mile and Ryan area in northeastern Detroit, was founded in 1939 for African-American Catholics who were refused admission to other nearby parishes by a few recalcitrant pastors. Race relations among the residents in this vicinity remained tense for the next several years, especially after the establishment of the Sojourner Truth Housing Projects on Nevada between Ryan and Mound Road in 1942. Throughout its history, Holy Ghost remained a small parish but dutifully served its congregation until African-Americans were gradually accepted into neighboring Catholic churches. Although the Great Depression had sapped the energies and finances of the Archdiocese, a far greater challenge, indeed, a threat to humanity itself, loomed just beyond the horizon.

Three
THE FORTIES
THE WAR AND ITS AFTERMATH

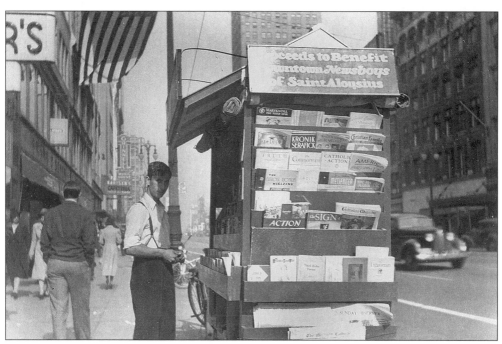

The St. Aloysius Newsboys Club sold a variety of Catholic publications to raise funds for orphans and other worthy causes. This newsstand operated at the corner of Grand River and Woodward in downtown Detroit in 1940.

Parishioners gather at the entrance of St. Francis d'Assisi Church on Wesson in Detroit in 1940 to mark the 50th anniversary of the parish. St. Francis was the second oldest Polish parish on the city's west side.

St. Jude Church, founded in July 1941 on Seven Mile and Kelly in northeastern Detroit, was among the first of several new parishes established in the city after the financially disastrous decade of the 1930s and one of the last to come into existence in Detroit until the conclusion of World War Two.

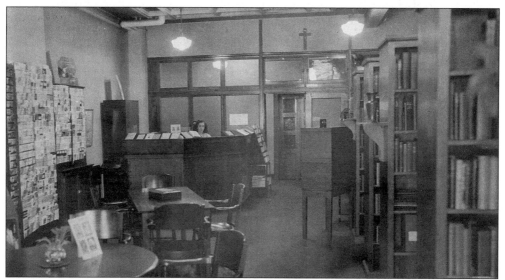

The Van Antwerp Library, shown here c. 1941, was located on the ground level of the Chancery Building in downtown Detroit. It afforded a quiet haven for office workers and shoppers to peruse religious books and periodicals. This site, on Washington Boulevard between State and Grand River, is currently home to the Catholic bookstore operated by the Archdiocese.

Msgr. Joseph Ciarrocchi, founding pastor of Santa Maria Italian Parish near the Detroit-Highland Park area, was the co-editor of an Italian language newspaper published in Detroit called *La Voce del Populi* (The Voice of the People). The newspaper criticized the brutal regime of dictator Benito Mussolini and warned that Italy's alliance with Nazi Germany would wreak havoc on the Italian people.

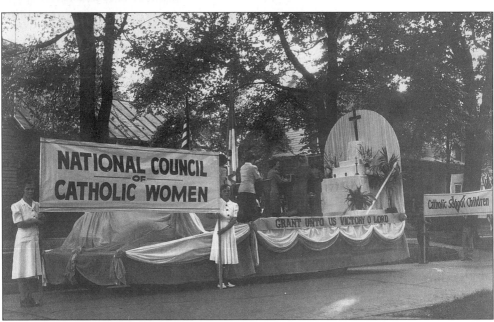

The Monroe chapter of the National Council of Catholic Women sponsored a victory parade in 1942 featuring this float to boost the public morale. Across America, the war took on the characteristics of a modern crusade, rallying the forces of democracy against world domination by the armies of totalitarianism.

A number of Archdiocesan priests served as chaplains during the Second World War, nourishing the spiritual needs of young men thousands of miles from home as well as tending to the grimmer tasks in the aftermath of battle. At left, Fr. Joseph Whelan and a young sergeant pray at the grave site of a fallen comrade during the bloody New Guinea campaign of 1943.

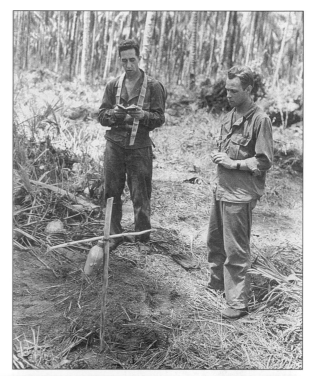

This side altar at St. Juliana Church in 1943 was decorated with miniature American flags, each representing a member of the parish who was serving in the military somewhere in the world. This type of memorial was common in Catholic churches throughout metropolitan Detroit, reminding parishioners to pray for a speedy end to the war and the safe return of their sons and daughters.

Detroit already had a small but growing Filipino community by 1943. The Catholic Filipino Club within the Archdiocese consisted of members who were born in the United States as well as refugees who fled their homeland to escape a harsh life under Japanese occupation.

Each parish had its contingent of women volunteers who worked on behalf of the Red Cross and the USO, donating their time and energy to the war effort.

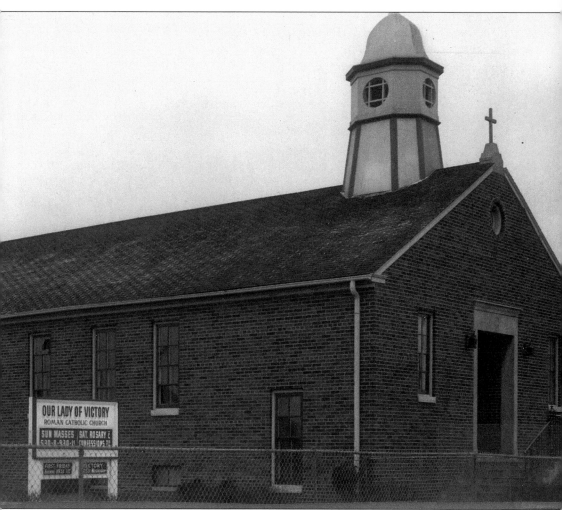

Our Lady of Victory Parish was founded in 1943 on Eight Mile and Cherrylawn near the African-American enclave of Royal Oak Township. African-Americans were again denied entry to neighboring parishes, prompting the establishment of Our Lady of Victory for them. Racial tensions were exacerbated in the aftermath of the 1943 riots, the worst in the city's history up to that time. In the ensuing years, tensions gradually decreased and by 1973, Our Lady of Victory merged with nearby Presentation Parish.

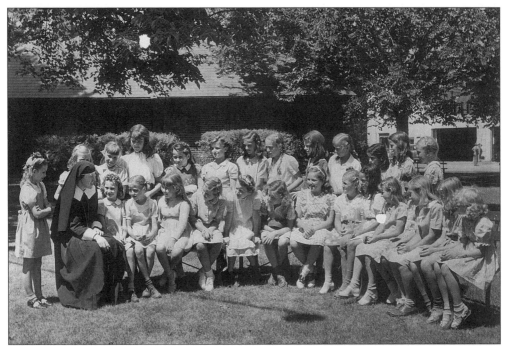

While the war raged overseas, children back home continued with their schooling. Here, a group of girls from St. Anthony Parish in Belleville, listen attentively to their teacher while enjoying the fresh air outside the confines of their classroom in 1943.

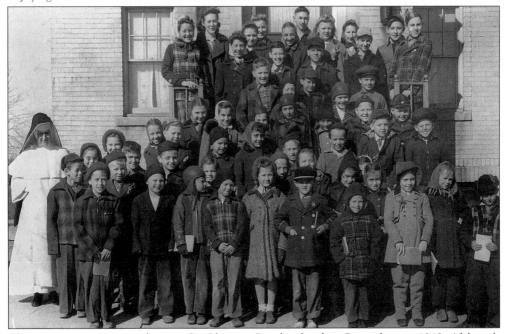

These youngsters were students at St. Clement Parish school in Centerline in 1943. Although Centerline is a busy commuter suburb today, located only minutes from Detroit, at that time it was still largely rural. The Racine Dominicans staffed the school, and are recognizable by their white habits with a dark veil (at left).

In 1944, a young Clement Kern took over as pastor of Most Holy Trinity Church on Sixth and Porter in Corktown, Detroit's old Irish section. For the next four decades, Msgr. Kern's selfless devotion to the poor led to the establishment of a free medical and legal clinic, food and clothing distribution, and housing and counseling services for those who could not afford them. At other times, a sympathetic ear and a hug from him were all that were needed to lift someone's spirits. In time, Msgr. Kern's efforts would earn him the affectionate sobriquet, "The Saint of the Slums."

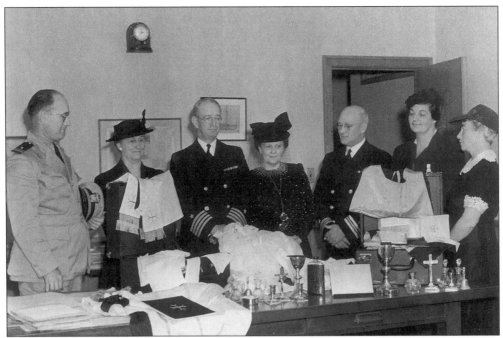

Members of the Detroit Council of Catholic Women exhibit the contents of a "chaplain's kit" to representatives of the different branches of the U.S. armed forces. The kits, paid for by donations to the council, contained a chalice, cruets, a crucifix, and other sacred vessels used by chaplains in celebrating Mass for soldiers on the front lines.

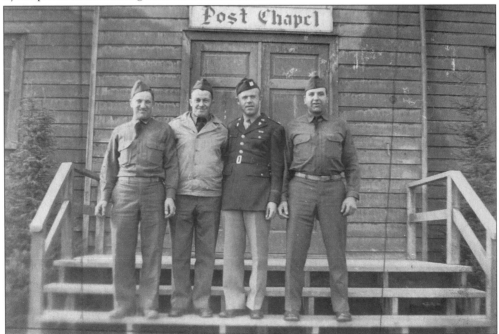

These four buddies stand before the post chapel, perhaps for a final service before being shipped overseas, c. 1944. Pictured, from left to right, are Private Elmer Camps, Private Earl Grosby, Chaplain Fr. Henri Hamel, and Private Michael Gross.

With so many men of the parishes serving in the military, the responsibility for fund-raising endeavors often fell upon the women's organizations. In lieu of cash donations, parishioners often gave a portion of their accumulated war bonds instead.

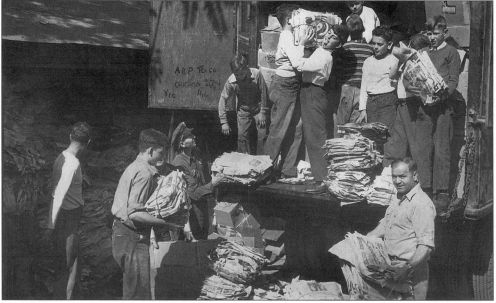

Symbolic of the war efforts on the home front, the now-famous paper drives brought young and old, parents and children together for a common cause. This hard-working group from St. Margaret Mary Parish on East Warren and Lemay in Detroit pitches in to load the truck in 1944.

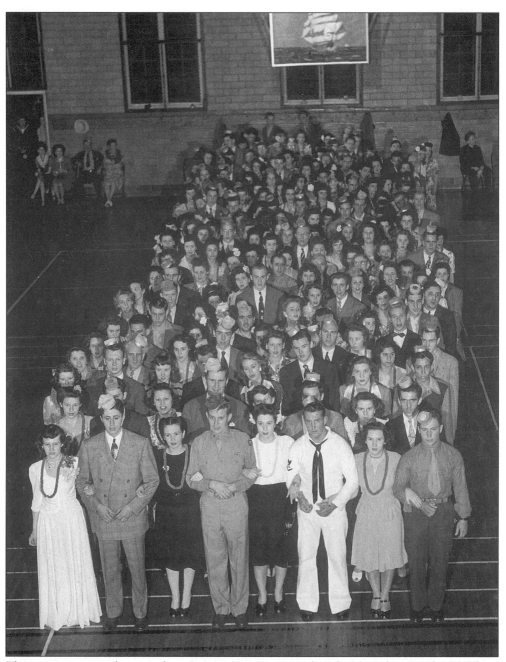

These young men and women from St. Margaret Mary Parish gather for a dance at the St. Claire Recreation Center in Detroit in June 1945. By this time, there was a real reason to celebrate as the most destructive conflict in human history neared its long-awaited end. Germany had surrendered unconditionally in the previous month and Japan's imminent defeat was but two months away.

The Vatican recognized the importance of Detroit within the American Catholic Church by making Archbishop Edward Mooney the first prelate in Archdiocesan history to be honored with the rank of Cardinal in February 1946. While in Rome to receive his red hat and ring, Cardinal Mooney poses with the Holy Father, Pope Pius XII.

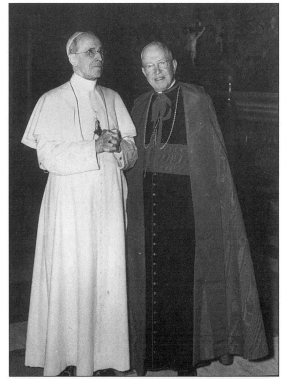

Children at the Wayne County Training School stand reverently after making their First Holy Communion in 1946.

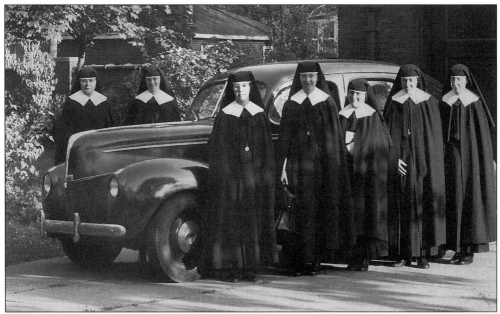

These Our Lady of Victory Sisters (sometimes called the Missionary Catechists) stand beside their automobile in Detroit in 1946. The order was founded in 1921 in the Archdiocese of Chicago to impart religious and practical Christian instruction to children and adults who did not have the opportunity to attend a parochial school.

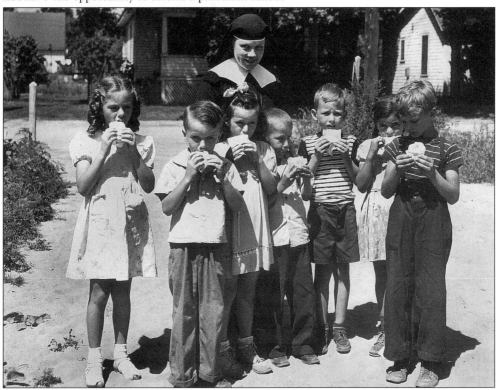

This Sister treats her young pupils from a summer Bible study class to some ice cream, *c.* 1946.

The herculean task of rebuilding a devastated Europe after the war was undertaken by the United States. The brilliant and timely Marshall Plan poured billions of dollars into the postwar efforts to restore the European economy. The National Catholic Welfare Conference initiated its own program to assist in the reinstatement of the Catholic Church in Germany, which had been suppressed by the Nazis. Aid packages included religious-themed books and Bibles both in English and German, rosaries, and medallions.

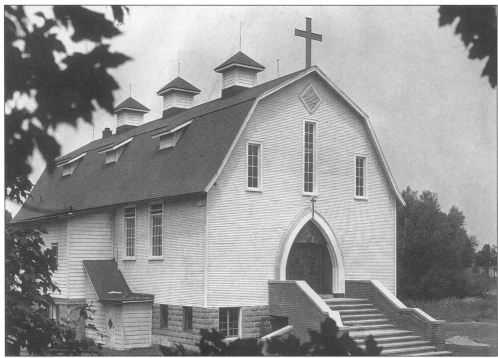

With its unmistakable shape, this former barn in the village of Warren became the first church for the fledgling congregation of St. Anne Parish on Mound Road, September 1946.

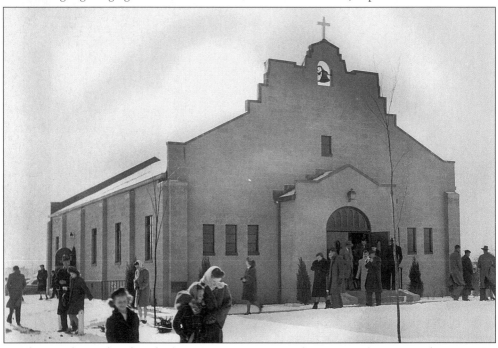

Parishioners leave the chapel of St. Anne, Monroe in the winter of 1947. At this time, St. Anne was not a fully independent parish but rather a mission of nearby St. John Church. This part of the Monroe area was referred to then as Detroit Beach.

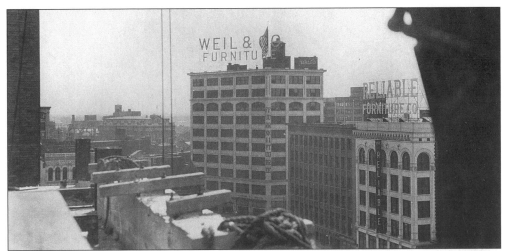

The former Weil Furniture Building at the corner of Michigan Avenue and Washington Boulevard was purchased by the Archdiocese shortly after World War Two and renamed the Gabriel Richard Building. The additional office space of the GRB permitted the Archdiocese to expand its social service programs, notably the resettlement of thousands of post-war refugees who emigrated to Detroit to seek work and rebuild their lives.

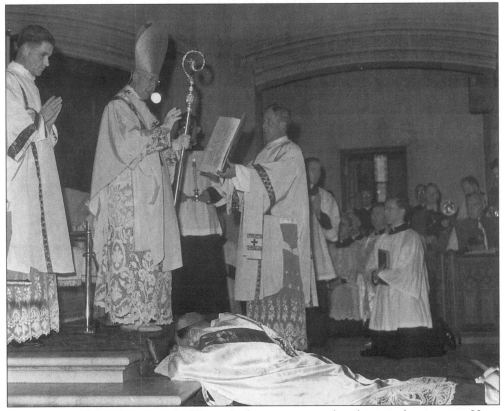

A growing Archdiocese required additional administrative and ecclesiastical assistance. Here, Cardinal Mooney ordains Msgr. Allen Babcock as a new auxiliary bishop in February 1947. Seven years later, Bishop Babcock would become the Bishop of Grand Rapids.

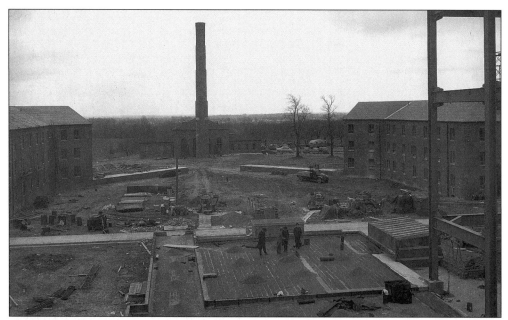

Cardinal Mooney, center, confers with the architect of St. John Provincial Seminary at the construction site of the new facility in Plymouth in western Wayne County, in 1947. St. John Seminary was established when the bishops of the five dioceses in Michigan at that time (Detroit, Lansing, Grand Rapids, Saginaw, and Marquette) unanimously concurred that such a school was needed to meet the increasing demand for priests across the state.

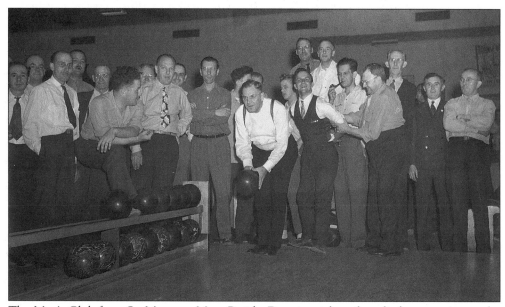

The Men's Club from St. Margaret Mary Parish, Detroit, gathers for a little recreation at the local bowling alley in 1948.

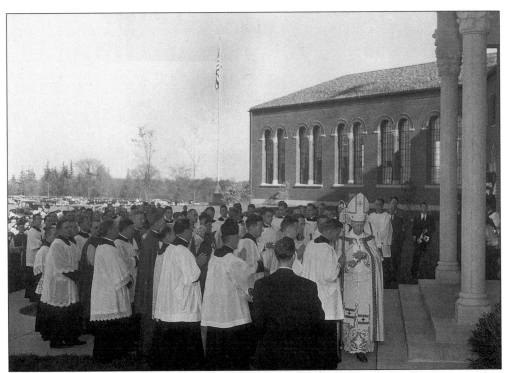

Cardinal Mooney presides at the dedication ceremony for St. John Seminary in 1948.

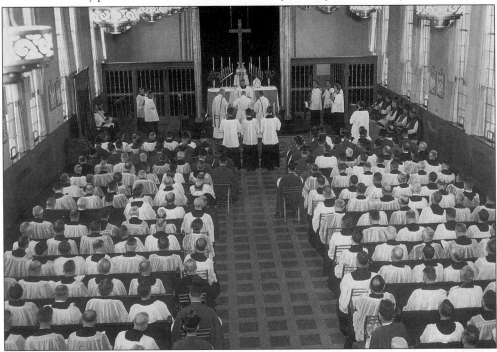

Until the completion of the seminary chapel, the library was temporarily pressed into service for worship. Here, priests, monsignors, and visiting bishops fill the pews at the 1948 dedication Mass at St. John Seminary.

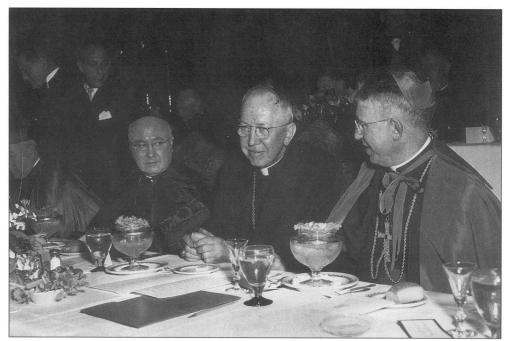

Beaming with pride, Cardinal Mooney, center, is flanked by two esteemed guests at the banquet marking the opening of St. John Seminary in 1948. At left is Cardinal Francis Spellman of New York, and at right, Bishop Joseph Albers of Lansing.

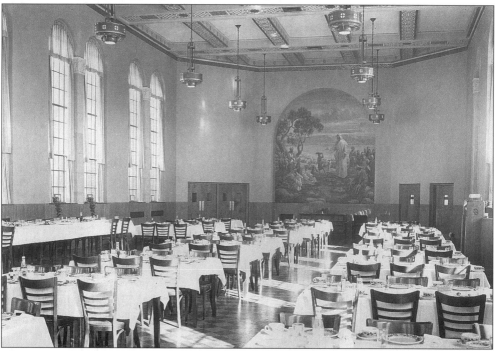

Thanks to many generous benefactors across Michigan, St. John Seminary was a modern, thoroughly equipped facility for the education of future priests. Pictured here is the seminary dining hall.

Like most boys at any Catholic school, this group looked forward to the noon recess so they could indulge themselves in their favorite pastime—a game of marbles, c. 1949.

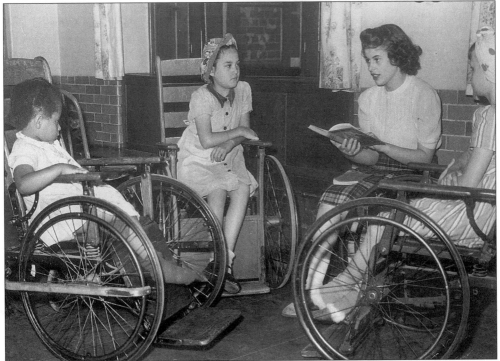

The Confraternity of Christian Doctrine was implemented by Cardinal Mooney shortly after his appointment to Detroit to ensure that Catholic religious instruction would reach the youth not enrolled in a parish school. The number of participants in the CCD program skyrocketed after World War Two. Here, a volunteer student reads to a group of physically impaired children.

After the war, building materials were in short supply as the nation's factories slowly moved away from war production back to civilian goods. Toward the end of the 1940s, the problem was alleviated and many long-delayed construction projects within the Archdiocese were finally begun. This sign, in front of St. Patrick Parish in White Lake c. 1949, reminded the congregation that a new church would not be possible without teamwork and sacrifice. As the 1950s dawned, the Archdiocese was poised for a decade of unprecedented growth in the Catholic population and expansion of its programs and ministries.

Four

THE FIFTIES

PROSPERITY AND

RENEWED GROWTH

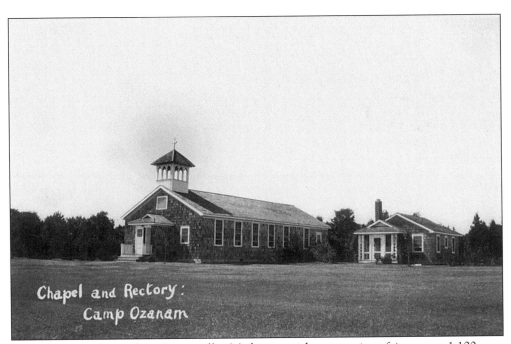

Camp Ozanam, located in Carsonville, Michigan, with a capacity of just over 1,100, was sponsored by the St. Vincent de Paul Society for boys from impoverished families. The camp was named after the Society's founder, Frederick Ozanam.

St. Mary Hospital, the first hospital in Detroit (1850), was on the verge of closing in 1950 when a group of physicians purchased the financially strapped facility from the Daughters of Charity and renamed it Detroit Memorial Hospital, hoping to prolong its usefulness to the community. The venture failed, however, and the hospital closed its doors permanently that same year.

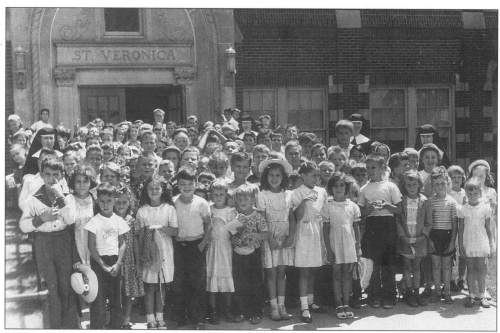

The post-war baby boom generation began to take root in American society, as evidenced by these students at St. Veronica Parish in Eastpointe in 1951. The sheer weight of the baby boomers' numbers prompted the need for construction of new schools and expansion of existing facilities throughout the Archdiocese, a trend that would not peak for another dozen years.

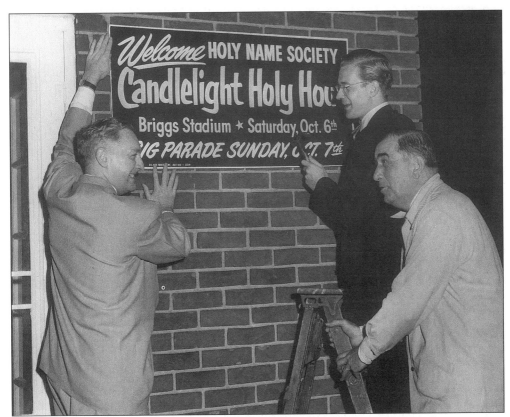

Detroit was the host city for a national convention of the Holy Name Society in October 1951, as part of the celebration of the 250th anniversary of the founding of the city. Note the sign reads "Briggs Stadium," the name for the home field of the Detroit Tigers at Michigan and Trumbull before it was christened Tigers Stadium.

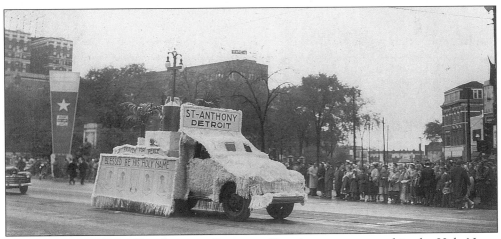

St. Anthony Parish on Sheridan near Gratiot in Detroit was represented in the Holy Name Parade along Woodward Avenue with this float in October 1951.

The Polish congregation at Our Lady Queen of Angels Parish on Detroit's west side organized a successful fund-raising campaign to begin construction of their new, more spacious church (the present structure) in the summer of 1952.

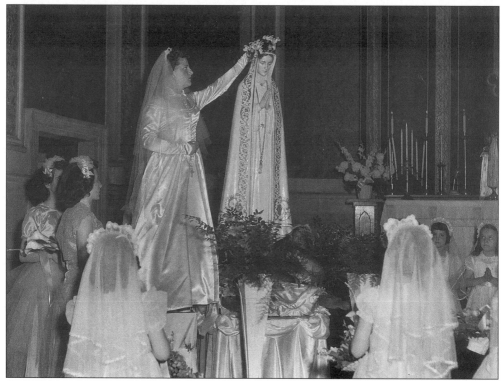

One of the more beautiful, memorable ceremonies in the Catholic Church was the annual May crowning of the Blessed Mother. Most schools in the Archdiocese marked the occasion with the requisite procession that included the entire student body.

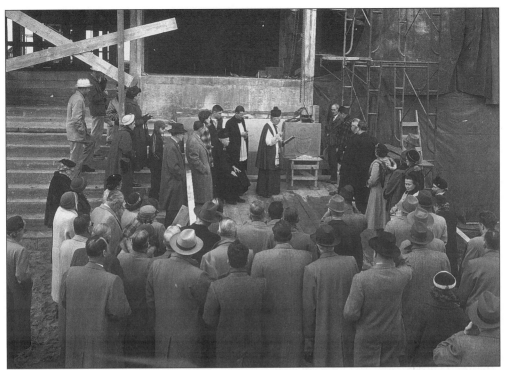

People gather for the blessing of the cornerstone of the new Mercy Hospital in Port Huron in 1953.

The women's religious order known as the Home Visitors of Mary purchased this house on Arden Park in Detroit's historic Boston-Edison district as their new convent, c. 1953-54. The order came into existence in 1949 with the approval of Cardinal Mooney. Their primary mission was to encourage lapsed Catholics to rejoin the Church, in addition to religious instruction for children.

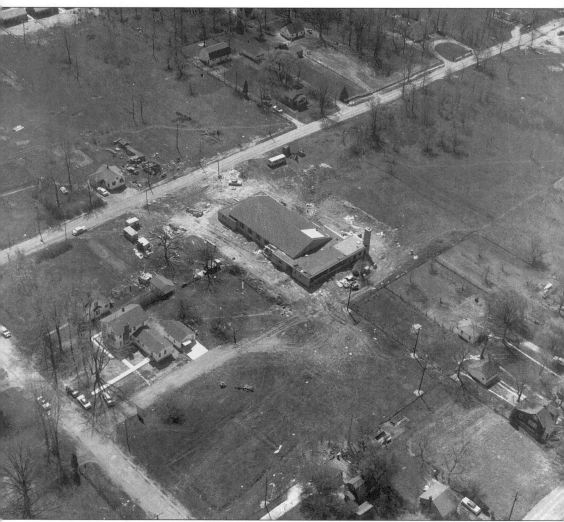

This view shows St. Eugene Church under construction in the Eight Mile-Berg area of northwestern Detroit in 1954. With a population growth that showed no signs of abating, Detroit pushed its boundaries to their farthest limits in the 1950s as new subdivisions filled the few remaining empty tracts of land south of Eight Mile Road. The vicinity around St. Eugene retained its quasi-rural charm for many years, but the parish itself was closed in 1989 as part of an Archdiocesan plan to reduce the number of underutilized facilities.

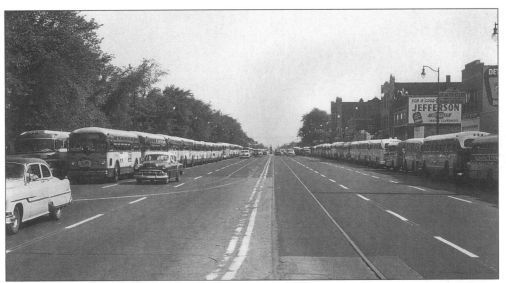

Buses are parked as far as the eye can see along Livernois near the University of Detroit campus in Detroit, bringing in thousands of Catholic visitors from throughout the state to participate in the Marian Year observance in 1954 that included a gigantic rally held at the university's stadium.

In the 1950s, increasing numbers of Mexican migrant workers made their way into Michigan seeking work on the state's many farms. The Archdiocese recruited different orders of nuns to ensure that these newcomers would not be inadvertently omitted from religious instruction programs. These Mexican Sisters demonstrate the proper way to use a rosary.

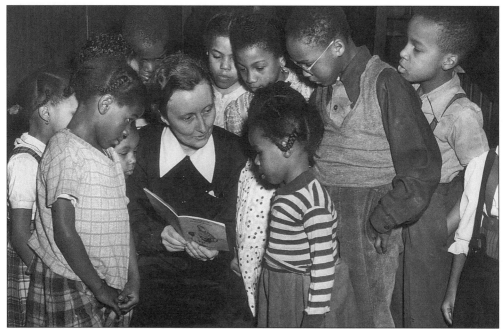

The Confraternity of Christian Doctrine program was particularly effective in teaching the Catholic faith to children who did not attend a parish school. This Home Visitor of Mary Sister reads to a group of African-American youngsters in the western Wayne County community of Inkster, *c.* 1954.

Cardinal Mooney stands with his three auxiliary bishops, *c.* 1955. Pictured, from left to right, are Bishop Henry Donnelly, Cardinal Mooney, Bishop Alexander Zaleski (who later became Bishop of Lansing), and Bishop John Donovan, who served as Mooney's secretary in the early years of his administration and would later become Bishop of Toledo, Ohio.

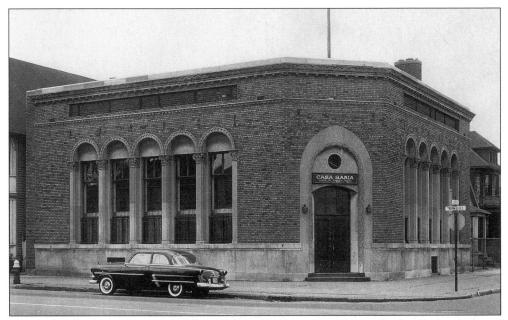

This former bank at the corner of Trumbull and LaBrosse near Tigers Stadium was purchased by the League of Catholic Women and converted into the Casa Maria Community Center. By the mid-1950s, Casa Maria provided an array of community services including children's activities, family counseling, and a neighborhood health clinic.

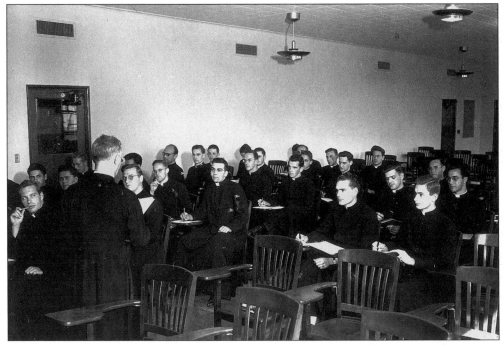

St. John Seminary's mission of educating candidates for the priesthood was a resounding success as the number of students grew with each academic year. By the end of the 1950s, nearly two hundred seminarians from across Michigan were in attendance at St. John. Here students listen to their instructor's lecture in Hebrew class.

Cardinal Mooney blesses the graduates at commencement ceremonies for the University of Detroit, *c.* 1955.

The Negro Apostolate organized by the Archdiocese assimilated African Americans into the Catholic Church and encouraged their participation in its administrative and charitable functions. The priests pictured here are members of the Passionist Fathers.

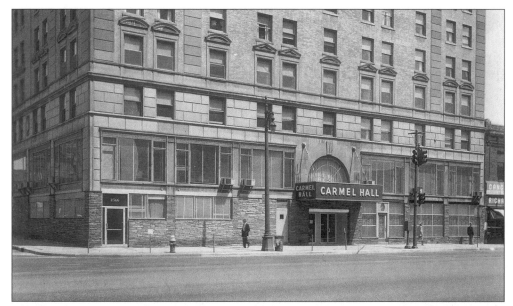

The Hotel Detroiter at the corner of Woodward and Adelaide was a notorious hangout for members of Detroit's crime syndicate during Prohibition. In June 1955, with grant money obtained from the Archdiocese, the Carmelite Sisters purchased the building and renamed it Carmel Hall. Originally, the facility was to serve as a retirement home for clergy, but instead it became a residence for the elderly.

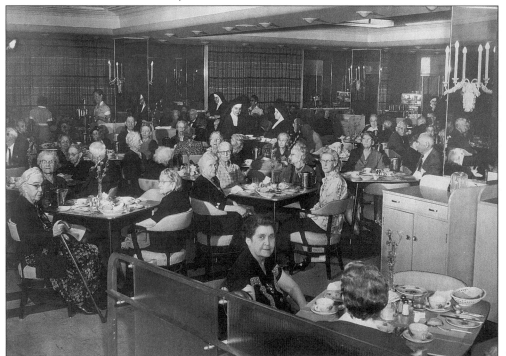

Sisters help out in the dining room at Carmel Hall, serving meals. The 1950s saw the beginnings of an increased awareness within the Archdiocese of the need to provide the elderly and infirm with a caring, dignified environment in which to live out their remaining years.

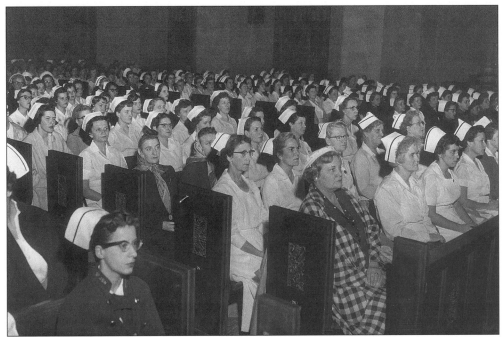

In recognition of the selfless devotion of professional nurses in Catholic hospitals throughout metropolitan Detroit, the Archdiocese honored them with the first so-called "White Mass" at Blessed Sacrament Cathedral in October 1955.

The Christ Child Society, headquartered at 91 Pallister between Woodward and Second just north of West Grand Boulevard, was a social service program sponsored by the Archdiocese that provided temporary boarding care for children and layettes for needy mothers.

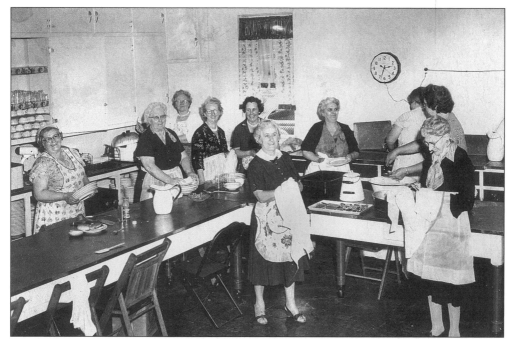

No parish festival could ever hope to succeed without the dedicated "kitchen ladies" who gave generously of their time and culinary talents preparing delicious meals for everyone's enjoyment. At one time or another, just about every mother or grandmother took her turn in the parish kitchen.

The St. Rose High senior girls' swimming team poses for a publicity shot for an upcoming meet c. 1956. Pictured, from left to right, are Geraldine Lane, Mary Burke, unidentified, Kathy Steendon, Barbara Schraeder, Kathy Martin, unidentified, Nicky Biondo, Gloria Trupiano, Joanne Moran (hidden from view), and Patricia Komanski.

The last new Catholic church ever built in Detroit was this contemporary design at St. Thomas Aquinas Parish, founded in 1955, on Evergreen and Ford Road on the city's west side. The area is historically known as Warrendale. Detroit's present boundaries were in place by this time and available vacant land had all but disappeared.

Michigan Governor G. Mennen Williams, wearing his trademark bowtie, was the honored guest at the dedication banquet for the new St. John the Baptist Ukrainian Parish school in 1956. St. John, located on Clippert and Martin south of Michigan Avenue on Detroit's west side, was the first Ukrainian church in the city (1908). At the microphone is the parish pastor, Fr. Stephen Pobutsky.

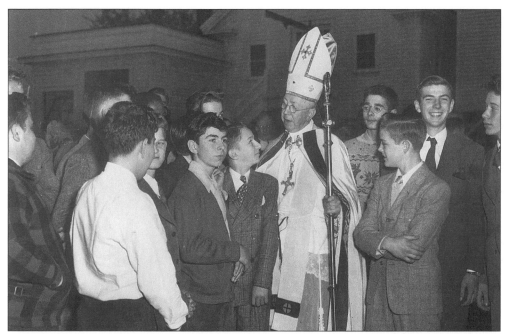

Cardinal Mooney chats with a group of boys after a parish visit. The Cardinal enjoyed every opportunity to mingle with children in an informal setting.

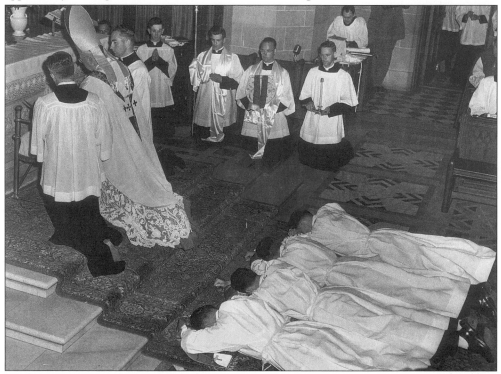

Cardinal Mooney leads the ordination ceremony for these new priests, c. 1956. With 40 new parishes added within the Archdiocese since 1950 alone, the need for priests was greater than ever.

The Archdiocese purchased this building on Hamilton in Detroit near the Highland Park boundary in 1956 and made it the headquarters for Catholic Social Services of Wayne County. The building continues to serve at this location to this day.

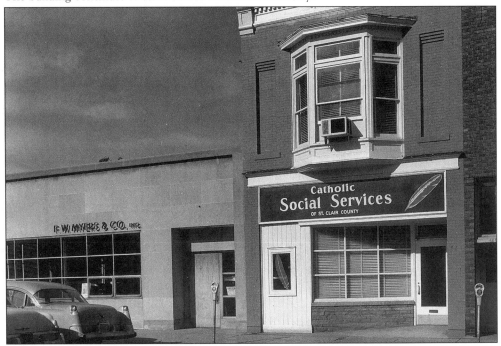

In the northern region of the Archdiocese, Catholic Social Services operated this branch agency for St. Clair County on Water Street in Port Huron in the mid-1950s.

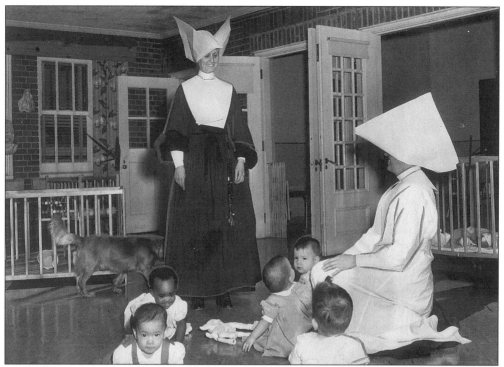

Immediately recognizable in their winged cornettes, these Daughters of Charity of St. Vincent de Paul watch over a group of infants at the Sarah Fisher-St. Vincent Youth Home. The home was originally founded in Detroit, then after the Second World War, relocated to a more modern, spacious facility on Twelve Mile Road in Farmington Hills.

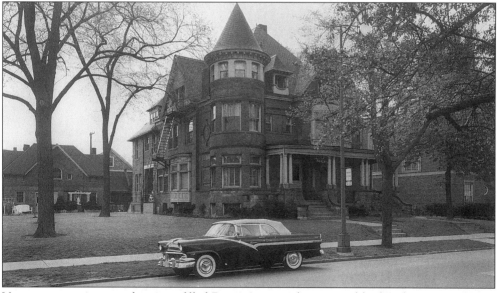

Victorian-era mansions that once filled Detroit's more elegant neighborhoods were sometimes refurbished to serve a new purpose. This former private residence at 215 West Grand Boulevard in Detroit became the St. Mary Home for the Aged, staffed by the Franciscan Sisters of St. Joseph.

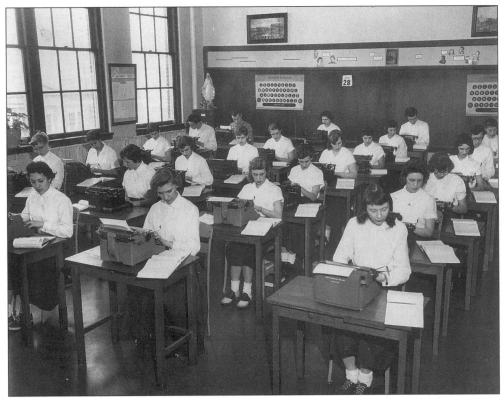

Speed, accuracy, and correct posture were emphasized for the students in this high school typing class at St. Mary Commercial, Detroit in 1956.

Cardinal Mooney takes a break from his hectic schedule for a few rounds of golf, c. 1957.

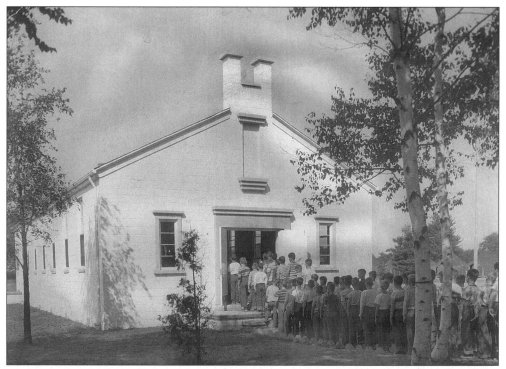

The League of Catholic Women sponsored summer camps for underprivileged youth as part of its community service mission. Here, boys line up to enter the chapel for Sunday morning Mass, c. 1957.

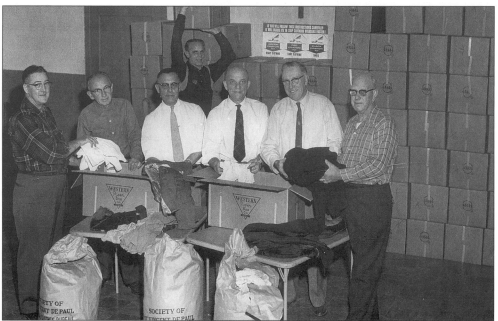

Catholics were often called upon to unite for a common cause outside their own parishes. This group of men works to prepare articles of clothing for shipment to a St. Vincent de Paul Society distribution center near Detroit's Greektown area.

Another example of a once-private residence that was given a new purpose was the St. Catherine Cooperative House for elderly women, 1958. It was located on Howard Street south of Michigan Avenue, just west of downtown Detroit.

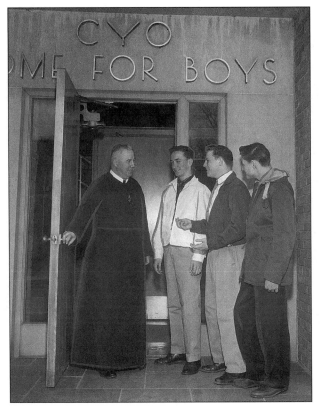

One of the best-known Catholic social service agencies was the Catholic Youth Organization. The CYO sponsored numerous youth-oriented programs including this home for boys on Petoskey Avenue on Detroit's west side.

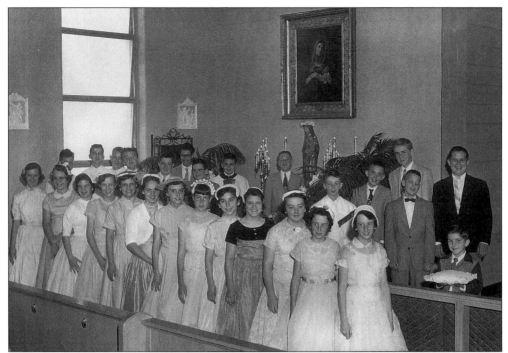

Our Lady Queen of Hope Chapel, on Archdale just off the Southfield Expressway, was built in 1956 to relieve the overcrowding at the main church, St. Mary of Redford on Grand River. In a few years, Queen of Hope would develop its own distinct congregation. These boys and girls comprised the chapel's confirmation class, c.1958.

Fr. Wilbur Suedkamp, shown here addressing a meeting of the League of Catholic Women in 1958, pioneered the development of affordable residences for the elderly poor in Detroit. As Director of the Catholic Charities Department, Fr. Suedkamp launched a series of nine such dormitory-styled apartment units throughout the Archdiocese that were collectively known as the Ryan Homes.

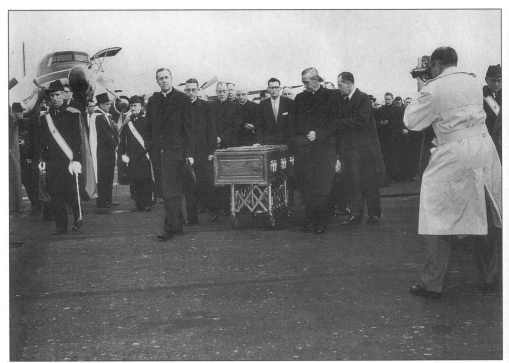

When Pope Pius XII died on October 9, 1958, Cardinal Mooney was among those summoned to the Vatican to cast a ballot for the new Pope. Ironically, Mooney himself died unexpectedly on October 25 while in Rome, and his body was flown back to the United States. Here a contingent of Archdiocesan dignitaries escort Mooney's casket at Detroit Metropolitan Airport, October 27, 1958.

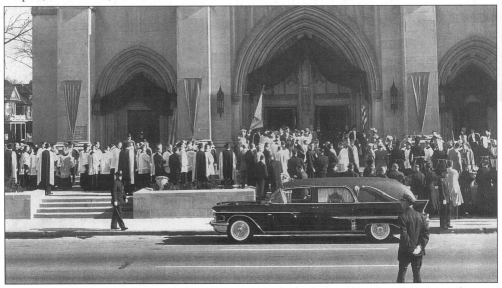

Persons gather at the entrance of Blessed Sacrament Cathedral on Woodward awaiting the start of Mooney's funeral service. The Cardinal's remains were placed in a crypt at St. John Seminary in Plymouth, and were eventually interred at Holy Sepulchre in Southfield when St. John closed its doors in 1988.

Bishop John Donovan, right, greets John Dearden, upon the latter's arrival as the newly appointed Archbishop of Detroit in January 1959. Archbishop Dearden, previously Bishop of Pittsburgh, came to Detroit with a reputation as a skillful administrator. His commanding physical presence and steadfast leadership inspired some persons to refer to the Archbishop as "Iron John." It was Dearden's work with the Second Vatican Council however, that would propel him to a higher level of respect and admiration in the eyes of both his ecclesiastical peers and the Catholic laity.

The older of St. Mary of Redford's two auxiliary chapels, Mother of Our Savior (1953), was located on Greenfield Road near the Jeffries Expressway. By 1959, the chapel had acquired a large enough congregation on its own that Archbishop Dearden elevated Mother of Our Savior to independent parish status in 1959.

The increasing popularity of television in the 1950s prompted the Archdiocesan Office of Communications, in cooperation with local television stations, to begin broadcasting liturgical services for shut-ins, c. 1959. The growing use of modern technology in its ministries heralded a new decade of transformation within the Detroit Archdiocese.

Five

THE SIXTIES

A CHANGING CHURCH

Bishop Alexander Zaleski (wearing the hat) shares a jovial moment with friends at the SS. Cyril and Methodius Seminary Founders' Day celebration, Orchard Lake, 1960.

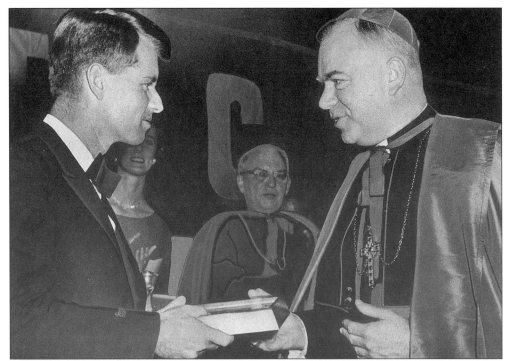

United States Attorney General Robert Kennedy receives the *Pro Deo et Juventute* (For God and Youth) medal from Archbishop Dearden at the National Catholic Youth Convention in Buffalo, New York, November 1961. The honor was bestowed upon the attorney general in recognition for his service on behalf of American youth.

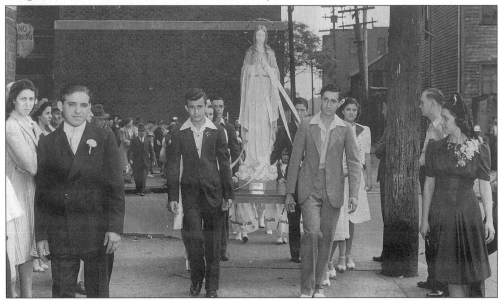

European immigrants faithfully maintained their native traditions in their new home in the United States and passed the familiar rituals down to their descendants. These Italian American parishioners at San Francesco Church near downtown Detroit venerate the Blessed Virgin Mary in May 1961, with an outdoor procession.

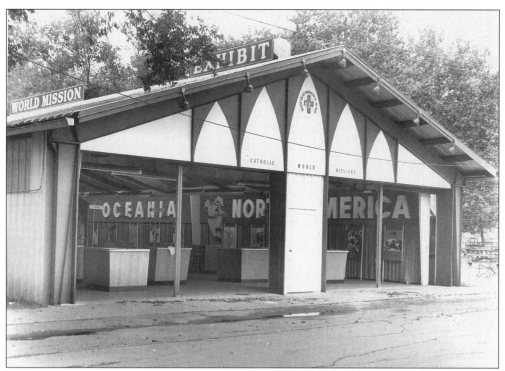

The international missionary work of the Propagation of the Faith Office is highlighted in this exhibit at the Michigan State Fair in Detroit, 1961.

The Cardinal Mooney Latin School opened its doors in 1961 as a high school with a curriculum that included seminary preparatory courses. It was located on the Sacred Heart Seminary campus on Linwood south of Chicago Boulevard in Detroit.

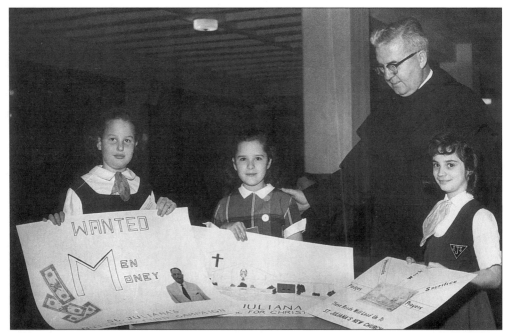

These students at St. Juliana School display their posters to announce the upcoming parish fund-raising campaign for a new, larger church, 1961. At right is St. Juliana pastor, Fr. Augustus Holloway, OSM, of the Servite Order.

Workers remove the few remaining interior fixtures from St. Wenceslaus Church on St. Antoine and Leland in Detroit prior to its impending demolition, 1962. St. Wenceslaus Parish, founded in 1870 for immigrants from the central European region of Bohemia, fell victim to a massive urban renewal project just south of the current Detroit Medical Center complex.

This First Communion class from St. Edward Parish on the city's lower east side in the early 1960s illustrates the changing demographics on that side of Detroit, with a greater percentage of African-Americans making up the area's Catholic congregations. Standing in the center of the top row is Fr. John Van Antwerp, St. Edward's pastor.

Local Catholic celebrities graciously donated their time on behalf of various charities and programs sponsored by the Archdiocese. Shown here in a promotional campaign for the Holy Name Society in March 1962 are, from left to right: Edward Kusak, president of the Detroit chapter of the Holy Name Society; Nick Pietrosante of the Detroit Lions; and Fr. Vincent Anuszkiewicz.

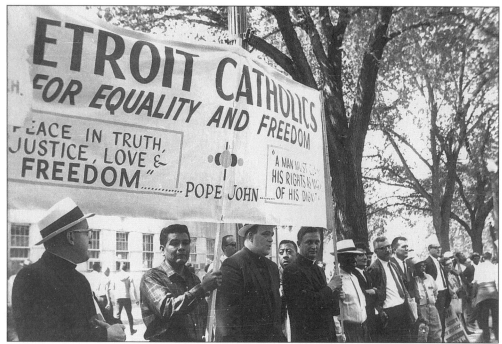

A group of concerned Catholics represented the Detroit Archdiocese at the Poor People's March in Washington, D.C., in August 1963. It was during this demonstration that Dr. Martin Luther King Jr. made his famous "I Have a Dream" speech that inspired and mobilized Americans in the national struggle for civil rights.

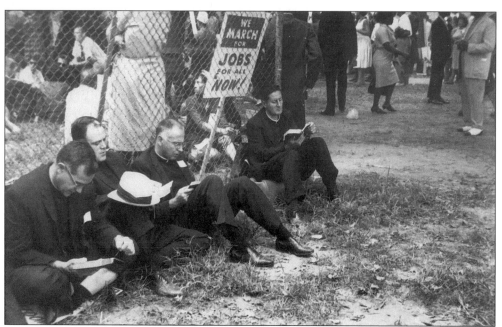

These participants in the Poor People's March rest alongside a fence, taking a break from the sweltering summer heat in Washington. One of the marchers is Fr. Walter Schoenherr, sitting third from left, who in May 1968 would be made an auxiliary bishop of the Archdiocese.

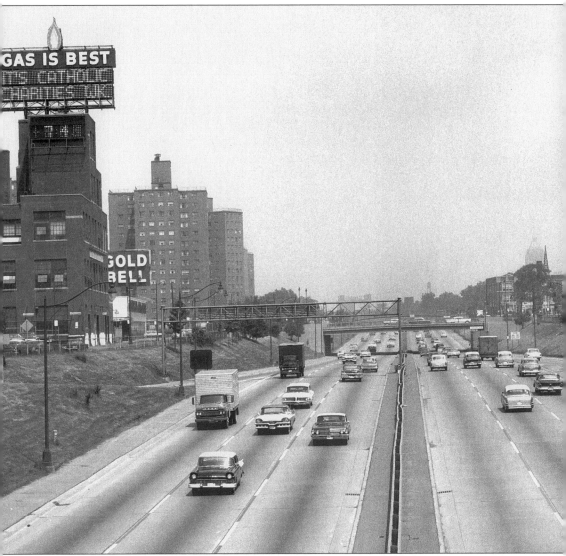

Commuters on the Lodge Expressway in Detroit are reminded on the message board belonging to the Michigan Consolidated Gas Company that "It's Catholic Charities Week," *c.* 1963. Statistically, the Archdiocese was nearing its historical peak in the early 1960s with just under 330 parishes, 365,000 students in the parochial school system, and a total Catholic population within its then eight-county jurisdiction of just over 1.5 million. In the city of Detroit itself, the Catholic population was estimated at more than 50 percent.

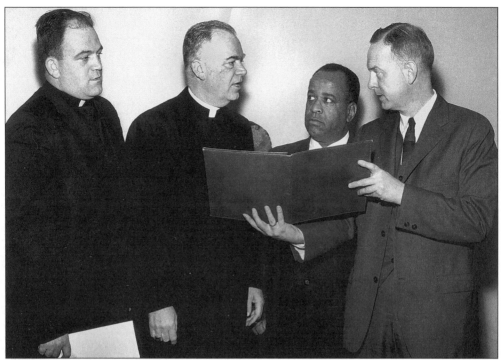

The Archdiocese used its considerable economic clout to pressure Detroit businesses to end their discriminatory hiring practices by refusing to patronize them. Reviewing the proposal for "Project Equality" are, from left to right: Fr. James Sheehan, Executive Director of the Archbishop's Commission on Human Relations, Archbishop Dearden, Lawrence Washington, Employment Services Chairman for the ACHR, and Thomas Gibbons Jr., Employment Services Director for the National Catholic Conference for Interracial Justice.

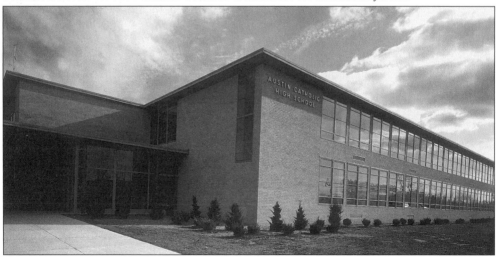

Austin Catholic High School was a private college preparatory school for boys run by the Augustinian Fathers. It was located on the far east side of Detroit, on East Warren near the Grosse Pointe boundary. In its peak years in the 1960s, the student body numbered 700, and the faculty staff stood at 25. A steadily declining enrollment however, led to the school's closure in 1977.

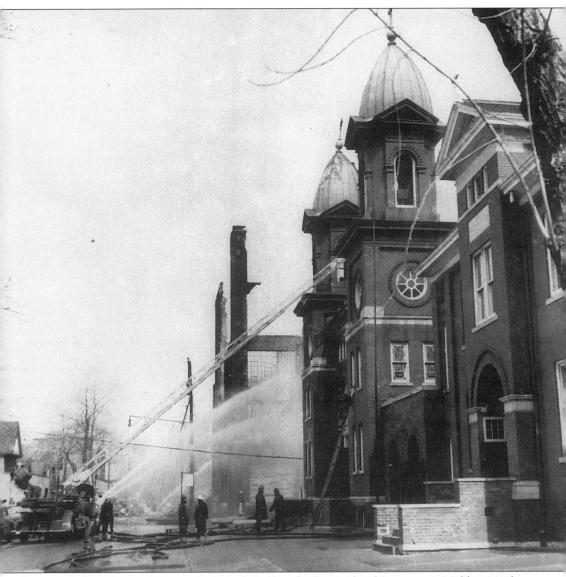

Detroit's Belgians were devastated when their church, Our Lady of Sorrows on Meldrum and Benson on the lower east side, caught fire in April 1963. The blaze broke out at a neighboring paint warehouse and quickly engulfed the adjacent church that dated back to 1908. Damaged beyond repair, the charred ruins were demolished. Thanks to a determined fund-raising effort however, the Belgian community rallied to erect a new structure of modern design on the same spot just one year later.

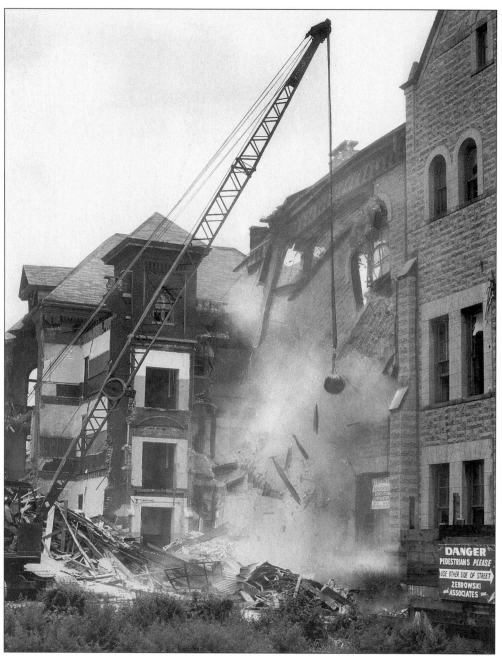

The venerable St. Joseph Parish, a downtown mainstay since 1856, opened a high school just prior to the beginning of the 20th century. Classes for boys and girls were conducted separately, taught by the Christian Brothers and the Immaculate Heart of Mary Sisters. Over the years, much of the aging residential area near St. Joseph had been systematically razed, resulting in fewer students at the school until it was finally forced to close in 1964. Demolition crews went to work shortly thereafter, dismantling the empty building.

Students everywhere looked forward to the day of the class outing or field trip, no matter what the destination was. Perhaps unknown to the students, their teachers had just as much fun as they did. Here a group of sisters enjoy the boat ride along the Detroit River on their way to the Bob-lo Amusement Park, c.1964.

Being a member of the safety patrol was quite an honor for many a young boy. Everyone took pride in knowing they were responsible for safeguarding their classmates' daily journey to and from school.

Outside of the diploma itself, the high school yearbook was undoubtedly the most treasured keepsake every student received, capturing those special moments that would be cherished decades later. The senior yearbook staff at St. Rose of Lima has its own picture taken for posterity, 1964.

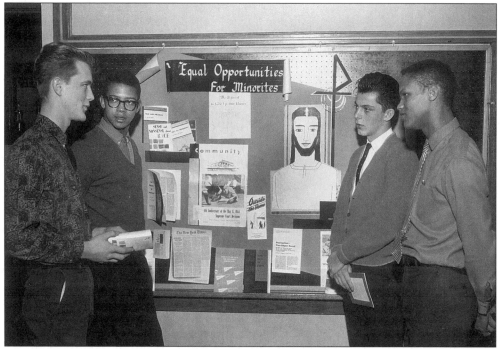

The national issues of race and civil rights eventually trickled their way into the classrooms of Catholic schools. Through exhibits and organized discussion, students were made conscious of the daily struggles and discrimination faced by racial minorities in American society.

Port Huron Catholic High School opened in 1961 to ensure that the educational needs of youths in the northern reaches of the Archdiocese would be met. Students and teachers here pose for a promotional campaign for the school, c. 1964. Ironically, the school would survive for only a decade, closing its doors in 1971.

Looking their angelic best, these altar boys stand before a creche, preparing for their role in the celebration of Christmas at their parish.

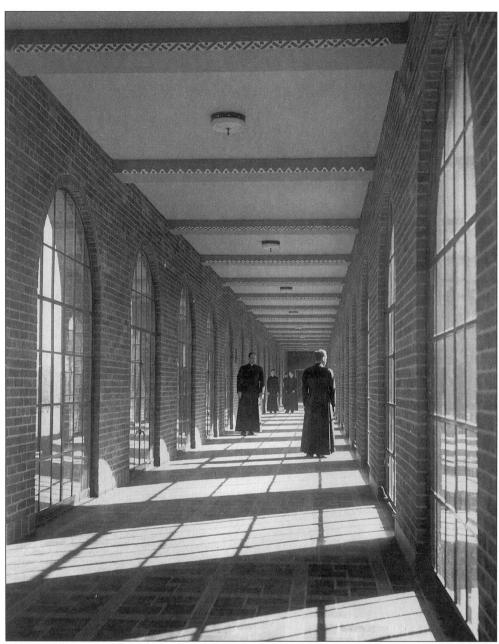

Bathed in sunlight, this cloister at St. John Seminary creates an ethereal, sanctified atmosphere befitting the institution's mission as a theologate. Enrollments at St. John climbed steadily through the mid-1960s, with the student body numbering 220 students. The Sulpician Fathers, made famous in the Detroit area by their best known member, Fr. Gabriel Richard from the early 19th century, continued to administer the school as they had since its founding in 1948. Seven Adrian Dominicans, meanwhile, were added to the school's support staff.

St. George Church, on the corner of Westminster and Cardoni in Detroit near Highland Park and Hamtramck, was the first Lithuanian parish in the city, dating back to 1908. As the Lithuanian community expanded into southwestern Detroit, other churches (St. Peter and St. Anthony) were founded for them. St. George was closed and demolished in 1965, due to the expansion of the Chrysler Expressway.

Like its sister chapel, Mother of Our Savior, the second of St. Mary of Redford's auxiliary chapels, Our Lady Queen of Hope developed a large enough congregation of its own that Archbishop Dearden declared it an independent parish in 1965. Queen of Hope likewise shared in Mother of Our Savior's fate in that it too was closed in 1989.

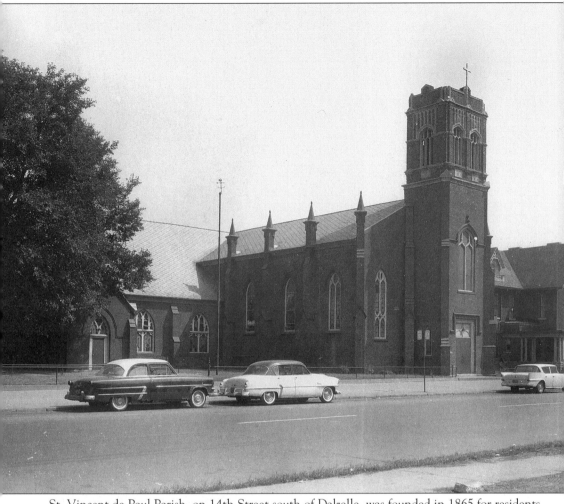

St. Vincent de Paul Parish, on 14th Street south of Dalzelle, was founded in 1865 for residents of Corktown when they could no longer be accommodated at Most Holy Trinity, the mother church for Detroit's Irish. St. Vincent evolved into one of the better-known Catholic parishes in Detroit, thanks to its well-reputed high school. The parish's location, close to downtown in the shadow of the Michigan Central train depot, would eventually doom it to extinction as the old residential neighborhoods around it were razed for a variety of urban renewal projects. The parish was closed in 1965, and its congregation merged with nearby St. Boniface. The entire physical plant, with the exception of the high school, was demolished. The St. Vincent Middle School, a merger of several area parish elementary schools, currently occupies the former high school building.

The Archbishop's Commission on Human Relations sponsored a "Human Dignity" conference in Detroit in April 1965, which brought national civil rights issues to the local level by formulating strategies to improve race relations within the Archdiocese. Conference attendees participated in what would be many such gatherings for this purpose in the years ahead.

Participants in the "Human Dignity" conference join hands at the conclusion of the program to sing "We Shall Overcome," the anthem of the civil rights movement.

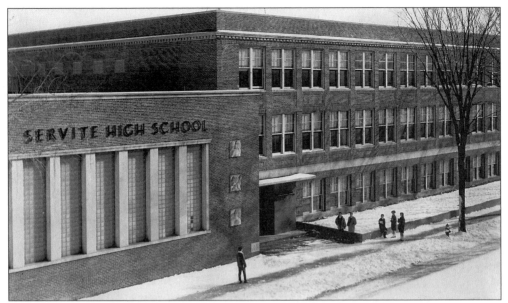

Servite High School, located on Coplin on Detroit's east side, was affiliated with St. John Berchman Parish, both of which were staffed by the Servite Fathers and Sisters. The popular, co-ed school at one time boasted a student body of almost 1,000 pupils in the 1960s but, like other Catholic schools in the city, was plagued by a dwindling enrollment in later years that brought the four-decade old institution to a close in 1987.

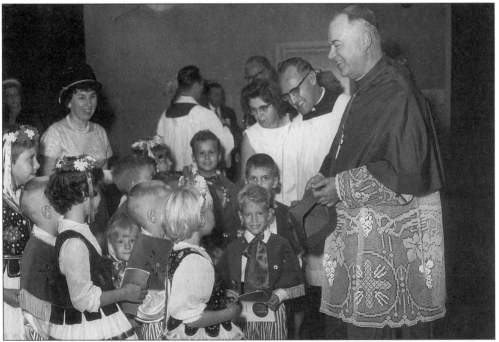

Dressed in traditional Polish costumes, these children bring a smile to Archbishop Dearden in a celebration at Cobo Hall marking the millennium of Polish Christianity, 1966. Standing to Dearden's right is Fr. Arthur Krawczak, who would be made an auxiliary bishop of the Archdiocese in 1973.

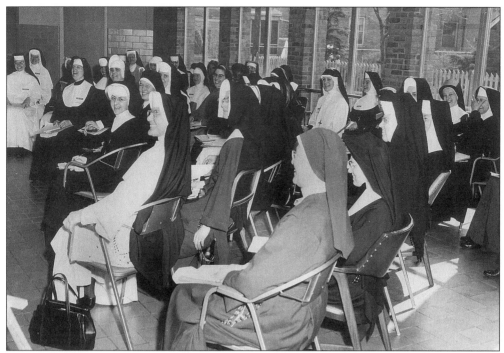

Sisters share some laughter at a conference sponsored by the Archdiocesan Council for Religious, 1966. The conference summoned representatives of the various orders in the Archdiocese to discuss ways of increasing the role of religious women within the Catholic Church.

Archbishop Dearden, second from left, participates in a symposium held at the University of Notre Dame to discuss the new ideas and proposals resulting from the Second Vatican Council, March 1966.

Detroit's oldest Italian parish, San Francesco, located on Rivard and Brewster just north of downtown, was established in 1896. In time, it would spawn other Italian churches, such as Holy Family (1907) and Santa Maria (1919). As Detroit embarked on a series of urban renewal projects however, the mother church for Detroit's Italians was destined to meet with a wrecking ball in 1966.

Another of Detroit's historic ethnic parishes, St. Joachim (1875), founded for the French parishioners of Ste. Anne (1701) who lived east of Woodward Avenue, was located downtown on East Fort and Dubois. Like its Italian counterpart, it too fell victim to urban renewal, closing in 1966 and torn down shortly thereafter.

After vacating its downtown location, the congregation of St. Joachim was relocated to this smaller, contemporary edifice on French Road directly across from Detroit City Airport in 1966. The sign highlights the parish's French Canadian origins, which included a Sunday Mass in French. The parishioners were served by the Holy Ghost Fathers since the beginning of the 20th century. The steadily shrinking numbers of French-speaking Catholics however, would compel the Archdiocese to close the church permanently in 1989. (Courtesy Dwight Cendrowski.)

This exquisitely detailed shrine stood in the garden courtyard at Our Lady of Help Church on East Congress and Elmwood, east of Woodward in downtown Detroit. The parish was founded in 1867 and catered to many ethnic groups, but beginning in the 1920s, saw an increasing percentage of Italians in its congregation. The church was demolished in 1968 for new apartments and retail businesses.

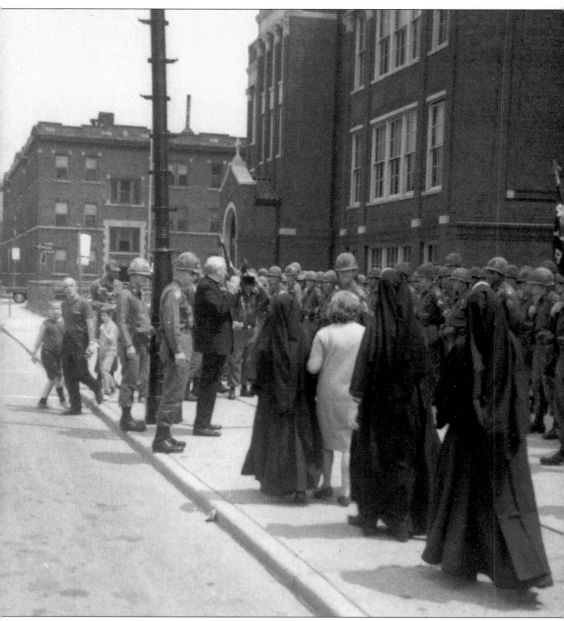

In July of 1967, the nation watched in horror and disbelief at the violence that erupted in Detroit during one of the worst civil disturbances in American history. The burning and looting that lasted a week resulted in dozens of deaths, hundreds of injured persons, and tens of millions of dollars in damage. President Lyndon Johnson initiated serious measures to quell the rioting, including the mobilization of National Guard units to keep the peace. This group of nuns hurries past a detachment of soldiers stationed at St. Rose of Lima Parish. The National Guard used the parish as a staging area from which to patrol the city's streets. Standing in the background facing the troops is Fr. George Gaynor, the pastor of St. Rose.

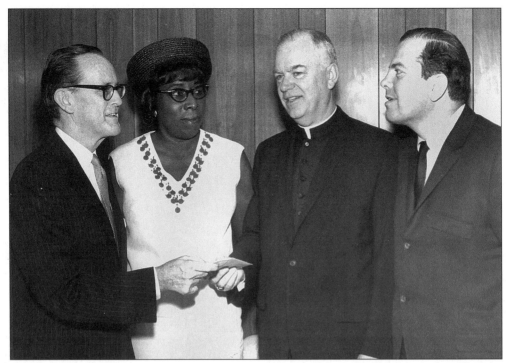

The Archdiocese co-sponsored a low-income housing project on Detroit's east side, called the Phoenix Homes, with seed money obtained through a federal grant. Presenting Archbishop Dearden with a check for over $200,000 is Michigan Senator Philip Hart, left, Annie Watkins, President of the Positive Neighborhood Action Committee and Detroit mayor Jerome Cavanaugh, right, April 1967.

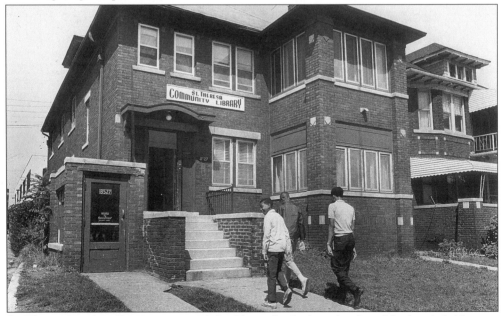

St. Theresa Parish in Detroit sponsored this library for the benefit of neighborhood children, to keep their abundant energies channeled into positive outlets.

Visitation Parish in Detroit was founded in 1920 and located on Twelfth and Webb. To the left is the parish high school that, during its peak years, averaged about 500 students. The parish's location near the heart of the riot-torn areas in Detroit prompted many concerned parents to withdraw their children from the school, which led to its closing in 1967. Rather than lament the loss of the old high school however, the Archdiocese took over the facility and opened the St. Martin de Porres High School in that same building. The new school gave inner city minority youths the opportunity to obtain a quality Catholic education and participate in an outstanding athletic program. Although Visitation Parish closed in 1989, St. Martin de Porres continues to thrive, currently operating in the former elementary school at Precious Blood Parish on Detroit's west side.

Another low-income housing project co-sponsored by the Archdiocese with federal and state grants were the Riverside Townhouses. Such residences became increasingly necessary to replace the city's aging housing stock, some of which dated back to the 19th century.

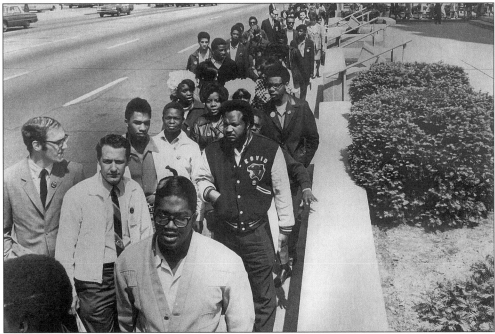

Catholic activism at the grassroots level gave rise to a host of neighborhood organizations that worked to improve the lives of Detroiters. These individuals gather for a meeting at Blessed Sacrament Cathedral, c.1968. The ESVID logo on the jacket of the man near the front of the line stood for "East Side Voices for an Independent Detroit."

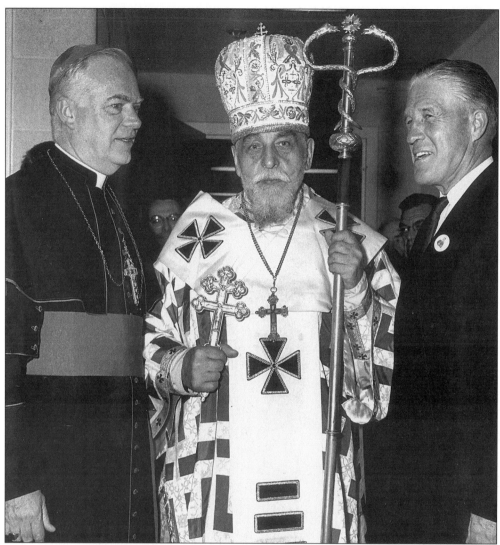

Archbishop Dearden, left, and Michigan governor George Romney, right, welcome Ukrainian Cardinal Joseph Slipyj to Detroit in August 1968. Cardinal Slipyj, ranking prelate for Ukrainian Catholics around the world, was imprisoned by Soviet authorities for two decades before his release in 1963 and eventual emigration to the West. The Cardinal's visit to Detroit that year prompted a hero's reception for him at Cobo Hall by the metropolitan area's Ukrainian community, which currently numbers an estimated 200,000 persons.

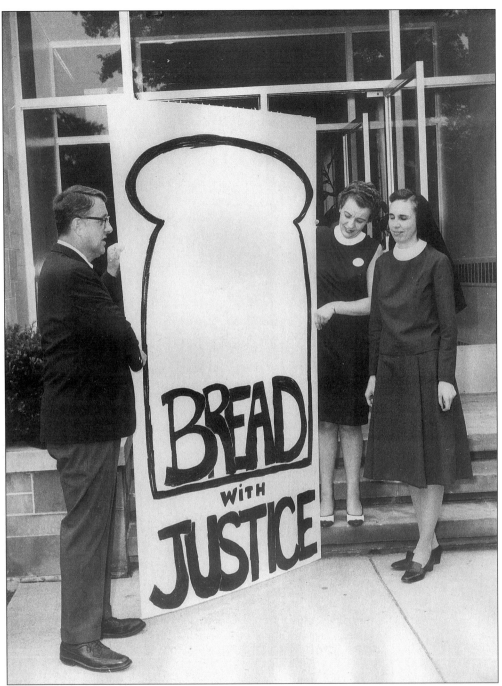

The Detroit chapter of the National Catholic Social Action Committee displays its idea for a promotional campaign, 1969. By the late 1960s, the United States faced a series of challenges to its way of life that some feared would destroy the nation: the war in Vietnam, disillusioned youth, and American cities torn apart by poverty, hatred and violence. The Catholic Church, on the other hand, relied on its own teachings that had been in existence for centuries to summarize what was needed to heal America's wounds—equality, justice, and compassion.

St. Edward Church, founded in 1927 on Crane and Kolb in Detroit's Indian Village, had the distinction of being territorially the smallest parish ever in the Archdiocese, having boundaries with a radius that extended only four or five blocks in any direction. In 1969, it was closed and merged with neighboring St. Catherine Parish.

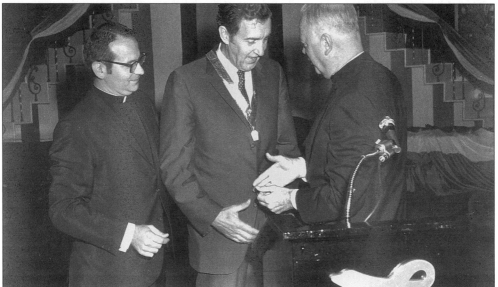

Senator Edmund Muskie of Maine is presented with the Fidelitas Medal by Cardinal Dearden in November 1969 at SS. Cyril and Methodius Seminary. The medal was awarded annually by the Orchard Lake Schools to an American Catholic of Polish descent for outstanding service to God and country.

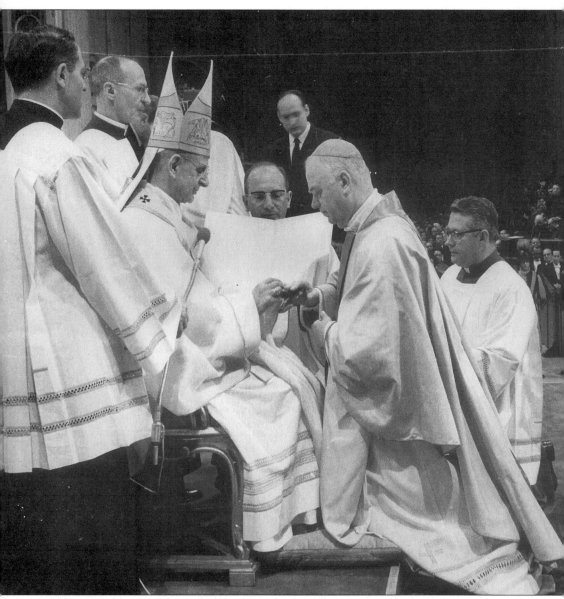

The spring of 1969 proved to be a watershed in Archdiocesan history. In March of that year, Archbishop Dearden initiated what came to be known as Synod '69, a conference or convention, the first of its kind anywhere in the nation, that would involve the laity to an unprecedented level in the reshaping of the post-Vatican II Church in Detroit. Just one month later in April, Archbishop Dearden followed in the footsteps of his predecessor, Edward Mooney, by being elevated into the College of Cardinals. Here, Cardinal Dearden kneels before Pope Paul VI to receive his ring and the Pope's blessings.

Although the Felician Sisters relocated to Livonia in 1936, their original motherhouse on St. Aubin and Canfield in Detroit across from St. Albertus, the city's oldest Polish parish, still served usefully in various capacities. It was a home for girls until 1964 and functioned also as a girl's academy until 1967. The Archdiocese operated a youth employment program within the building until 1969, when a fire destroyed the aging structure. Presently an apartment complex occupies the site.

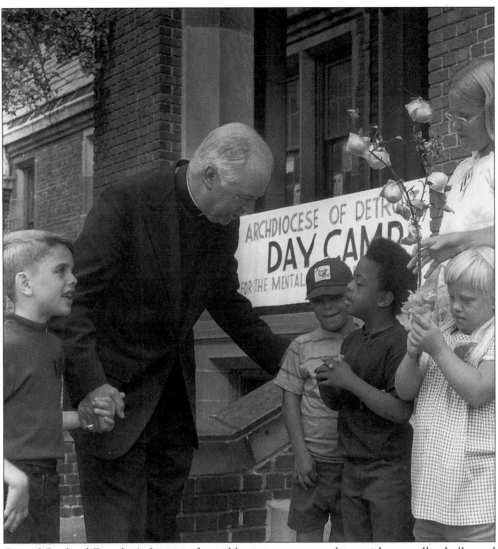

One of Cardinal Dearden's favorite charitable projects was working with mentally challenged children. He relished every opportunity to become involved on behalf of exceptional youngsters and, when his busy schedule permitted it, would visit them personally. Here the Cardinal spends time with some of his young friends at a day camp sponsored by the Archdiocese, 1969.